FROM THE LIBRARY OF

GARY METZ

A 1972 GRADUATE OF VISUAL STUDIES WORKSHOP, GARY METZ WAS
AN ACCOMPLISHED PHOTOGRAPHER AND NOTABLE SCHOLAR.

OCTOBER 14, 1941 – SEPTEMBER 28, 2010

photo text **text** photo

photo text **text** photo

The Synthesis of Photography and Text in Contemporary Art

Edited by Andreas Hapkemeyer and Peter Weiermair

EDITION STEMMLE

Contents

Works provided on loan by

Le Case d'Arte, Milan
Galleria Rino Costa, Casale Monferrato
Deutsche Bank AG, Frankfurt am Main
DG Bank, Frankfurt am Main
Sammlung FER, Laupheim
Sammlung Heinrich Gasser, Bozen
Sammlung Goetz, Munich
Galerie Bärbel Grässlin, Frankfurt am Main
Galerie Cora Hölzl, Düsseldorf
Institut für Auslandsbeziehungen, Stuttgart
Interim Art, London
Sidney Janis Gallery, New York
Galerie Françoise Knabe, Frankfurt am Main
Galerie Ursula Krinzinger, Vienna
Galerie Yvon Lambert, Paris
Collezione Pasquale Leccese, Milan
Museum Ludwig, Cologne
Massimo Martino S.A., Lugano
Collezione Egidio Marzona, Villa di Verzegnis
Museion – Museo d'Arte Moderna, Bozen
Collezione Marco Noire Editore, San Sebastiano / Po
Annina Nosei Gallery, New York
Galerie Rüdiger Schöttle, Munich
Monika Sprüth Galerie, Cologne
Edition Staeck, Heidelberg
Galerie Tanit, Munich

and other donors who wish to remain unnamed.

Preface

The exhibition entitled "photo text text photo" has its roots in the mutual interest in this theme on the part of the Frankfurter Kunstverein and the Museum für Moderne Kunst in Bozen. The role of photography and the printed word in contemporary art have always represented important cornerstones in the program of the Frankfurter Kunstverein; for many years, the theme of "language and art" has been a strong focus of attention in the predominantly, although by no means exclusively, historically oriented collection and exhibition efforts of the Bozen Museum.

Having recognized that the use of photo-and-text combinations of various kinds in art has become noticeably more prevalent over the past thirty years, and that as yet, however, no comprehensive comparative presentation has been devoted to this phenomenon, we have decided to fill the existing gap with both an exhibition and a catalogue.

It has been clear from the very beginning that our goal could not be a general survey, but rather a representative selection of artists and works. Furthermore, we have agreed that the selection should include only those artists for whom both media are of crucial importance. In some cases, a single artistic position would also incorporate similar strategies employed by other artists. We were also united in recognizing that the exhibition should cover a limited period of time (1967 to 1996), within which artists of diverse conceptual provenance have practiced the strategies in question. Historical aspects are to be treated in the catalogue.

The exhibition underscores the fact that the combination of photo and text as an artistic strategy is not an unusual practice but an approach that casts light upon many important areas and issues relevant to modern or contemporary art. Of central importance are efforts – typical of modern art – to overstep and to blur genre boundaries, mixtures of "high" and "low" at the level of content and reflections on linguistic ready-mades in the tradition of Marcel Duchamp. The fundamental differences in the functions and perspectives assigned to image and language within one and the same work are impossible to ignore.

A common interest in the theme logically heightened the appeal of cooperation between our two institutions. Our thanks are due above all to the artists, whose statements contribute in a real way to a better understanding of their work, to publisher Thomas N. Stemmle for his interest in the project and to the numerous donors of works on loan for their generous support.

Andreas Hapkemeyer
Peter Weiermair

Image and Word, Photo and Text

Mélisande ne cache pas,
mais elle ne parle pas.
Telle est la Photo:
elle ne sait dire ce qu'elle donne à voir.
Roland Barthes, *La chambre claire*

Marcel Duchamp's shaved Mona Lisa

Marcel Duchamp's *Mona Lisa. Rasée* was completed in 1965.[1] It is based upon an unaltered photographic reproduction of Leonardo's painting appropriated by the artist. In one sense, Duchamp forges a direct link to his earlier conceptual pieces, which were based upon the alteration of context for found objects and, as seminal works, have since taken their place among the most significant icons of modern art. In another sense, this work can be viewed as a kind of starting signal for the emergence of Conceptual Art in the mid-1960s, a movement that took the modernist agenda to its outermost limits.

The photograph of the Mona Lisa, mounted by Duchamp on a white background, is identified as a dual citation by the sub-title *Rasée*. Duchamp calls to mind his famous 1919 work in which he blasphemously painted a mustache on the enigmatically smiling figure. Like the famous *pissoir*, the photograph constitutes the unaltered appropriation of a previously existing representation of a work of art, and is thus a ready-made once removed. The photo per se stakes no claim to artistic quality; it is simply a found object. In contrast to many photographers, this still applies to a great extent to artists who combine photography and text in their work today. They are not concerned with the solution of technical problems in photography but instead with exploring ways in which (artless) self-made and appropriated photos can be employed as fully valid signs in an aesthetic communication process:[2] Barbara Kruger, for example, and Jochen Gerz express themselves in this sense; like other artists, they occasionally extend the use of the ready-made to their texts as well.[3] Through this operation, based upon the linking of a photo with a text, a conceptual – i.e. mental – interchange of ideas takes place between the 1919 work, Leonardo's original and the variation completed in 1965. The Dadaist attack upon a cultural icon is apparently negated by the artist's renunciation of the mustache in the latter work, but its presence is maintained indirectly in the ironic title incorporated into the picture.

The combination of photography and text in Duchamp's work has paradigmatic character. It represents a characteristic type of work in modern art. Like the early collages of Picasso or Braque, for example, Duchamp's photo-text combination oversteps the boundaries of genre, which, as expressed in Lessing's *Laokoon*, clearly distinguish between painting (in its manifestation of simultaneity) and text (in its reliance upon chronological sequence). Duchamp is thus one of the forefathers of the particular modernist tradition that operates between image and text, beginning at the latest with Cubism and continuing through the works of the Futurists, Dadaists, Constructivists, etc., into our own time.

[1] Dieter Daniels, "Varianten zur Mona Lisa" in *Übrigens sterben immer die anderen. Marcel Duchamp und die Avantgarde seit 1950* (Cologne: Museum Ludwig, 1988), pp. 68–72.
[2] See the exhibition catalogue *Konstruktion Zitat. Kollektive Bilder in der Fotografie* (Hanover: Sprengel Museum, 1993).
[3] See Barbara Kruger, *Buchstäblich. Bild und Wort in der Kunst heute* (Wuppertal: Von der Heydt-Museum, 1991), p. 76; see also Jochen Gerz, "Wörter und Bilder," in Erich Franz (ed.), *Texte* (Bielefeld: Kerber, 1985), pp. 164.

Word versus Image

The image (photo) essentially provides an ambiguous, and therefore vague framework of associations. Pictures, particularly photographic ones, are capable of affecting the emotions, expressing or activating memories, desires and even fears. The image defines an object in its visual manifestation without ambiguity but cannot make reliable statements about the possible meanings or implications of that object. And this is precisely the sense in which Roland Barthes' statement, cited above, is to be understood. If we distinguish – as Michael Titzmann does – between meaning and information, identifying the former with "linguistic articulability," then pictures have no "meaning."[4]

While the image is characterized by the concreteness and completeness of all visual elements, every "world" depicted via text remains abstract and incomplete. Semiologists refer to the "zero positions" of text. The ruler in Kosuth's photo in *One and Three Objects. Ruler* is precisely defined in visual terms; the word "ruler," on the other hand, denotes all conceivable rulers in the world. Exceptions, of course, are examples of Concrete Poetry in which the text makes no references to non-linguistic phenomena but is in itself the object of scrutiny.

"As we know, the basic difference between the semiotic systems of images and texts consists in the lesser degree of coding of the primary signifiers [i.e. the simplest elements capable of bearing meaning] in the pictorial and the higher degree of coding in the linguistic form. For whereas the linguistic system determines which elements differentiate and bear meaning ... this is not true of the primary signifiers in iconic expressions. Every perceptible element – a line, a shape, a color, every part of such an element and every combination of such elements – can, but need not, serve as a differentiator or a bearer of meaning ..."[5] Thus in semiotic terms the image is a continuum of signs with unclearly specified meanings, which derives its structure only from the projection of possible meanings (in the form of language) onto it.

The expression of unambiguous substantive meaning, therefore, cannot be accomplished without the word. Language, while incapable of defining an individual object of reality unmistakably – being able at best to approach it through the process of naming – can indeed precisely specify emotional or intellectual content and provoke questions.

Through the interaction of different media within a single work, through the combination of two different systems, photo-texts – like all combinations of image and text – are capable of operating on two levels. Images are semanticized by virtue of the direct allocation of texts; an explicit level of meaning is incorporated into the image. Texts, on the other hand, are unmistakably referentialized through the assignment of images. The disadvantage is that the work splits into two parts: one that is only to be viewed and another that can only be read.[6] The advantage, however, is that more complex information, in an aesthetic sense, becomes possible. Text and image can complement one another, the text precisely specifying an event depicted in the image by naming it, for

[4] Michael Titzmann, "Theoretisch-methodologische Probleme einer Semiotik der Text-Bild-Relation," in Wolfgang Harms (ed.), *Text und Bild, Bild und Text, DFG-Symposion 1988* (Stuttgart: Metzler, 1990), p. 371.

[5] ibid., p. 377.

[6] S. J. Schmidt analyzes the different functions of seeing and reading and their antithetical relationship in works of this kind ("Sehen oder Lesen? Vom Umgang mit Texten, die keine Bilder sind und umgekehrt," in Günther Dankl, Andreas Hapkemeyer (eds.), *Kunst und Sprache. Beiträge des Heinz Gappmayr-Symposions, 1990* (Piesport: Ottenhausen, 1991), pp. 38 – 45.

example. The text may just as easily work against the message of the image, however – as in Blum's work, for instance, in which the photos of three soldiers are unexpectedly given the names of three archangels: a question-provoking tension is created. Finally, the text may inject a level of meaning not foreseen in the image by introducing a new theme – the combinations of Faucon or Jochen Gerz come to mind, as do the works of Karen Knorr, in which the text opens up the image to new meanings.

In general, it is clear that "Where an image is embedded in text or where image and text are co-equal, textual semantics dominate over the semantics of the image and assume the function of structuring meaning: interpretation, focusing and establishment of hierarchies with respect to the image are all dependent upon the meaning supplied by the text, to the extent permitted by its particular features ... Thus a photo title, for instance, has a controlling effect upon the interpretation of the image."[7]

In certain cases – in the work of Urs Lüthi, Gilbert & George, Doherty and Richon, for example – the text within the photo is actually a title. In this way the printed word becomes an aesthetic component of the visual manifestation. The tension between verbal and iconic information generated by meaningful titles placed in the foreground of photos – as in the function of the indicator in Paolini's *Young Man Gazing at Lorenzo Lotto,* in Gappmayr's photographic works or in Sugimoto's seascapes – is incorporated into the image in the photo-and-text work and communicated visually.

Self-Reference
By virtue of his special position, which through the introduction of the ready-made breaks down the boundaries between art and life, on the one hand,

and instigates a self-reflection in art, on the other, Duchamp stands at the point of origin for two lines of development that extend, *mutatis mutandis,* into our own time.

The issue addressed by Duchamp in his Mona Lisa is certainly the alteration of context – but it is the alteration of context as relates to an object of art – and thus attention is focused upon the internal dynamics of the artistic process. From this standpoint he can be regarded as a precursor of a such strongly self-referential art as Concept Art (a connection can also be made to Louise Lawler, an artist of the 1980s, who continually refers in her photographic pieces to actual works of other artists). The revolutionary works of the American Conceptualists appeared at nearly the same time as Duchamp's shaved Mona Lisa – Kosuth's series *One and Three Objects,* for example: the individual *Protoinvestigations* oscillate between the presentation of an object in its physical singularity, its photographic and thus reproducible image and its totally open-ended linguistic definition. This series, in its own way a continuation of a line of inquiry developed in the course of the medieval debate on nominalism, employs a variety of everyday objects to expose the extremes of self-referentiality of the modern work of art.

Photo and text are identical in both Kosuth's definitions and Robert Barry's photo-text works of the early 1970s. Whereas Kosuth photographs a definition from a dictionary, Barry photographically reproduces single words and projects them onto a wall, the words forming word-groups in consecutive sequence. Since the words do not denote objects, however, but merely list general properties of objects nowhere named, the result is an extremely immate-

[7] Titzmann, p. 382.

11

rial work. Through the use of the photograph, the artist is able to eliminate, among other things, every trace of a personal handwriting. Maurizio Nannucci employs – via photography – finished pictures as examples with which to visualize and question preconceptions about art, philosophy, music, etc.

One of the great accomplishments of the avant-garde was its success in liberating art from its centuries-old dependence upon literature. If we consider that photographs represent a form of privileged access to our conception of reality and that the word quite naturally forges a bond with literature, then we may find it surprising that photo-texts, of all forms, occupy one of the most extreme positions in this process of liberation.

Although quite different in terms of their intentions, artists operating between concept and action also make use of photography in order to capture their actions, which are time-dependent and would otherwise be entrusted only to the memory of those present, or to make them available to the market (Beuys, Acconci, Gilbert & George, Fulton). The essential ingredient of the work of art is an act; its depiction in a photographically fixed image is, to be exact, a surrogate. The text added to the photo re-establishes the connection to the action, its conditioning circumstances and its intentions, which would be only insufficiently inferable on the basis of the photograph alone. Douglas Huebler's *Duration Pieces* make visible the unique quality, the irretrievable character of a single moment of a process with the aid of photographic fixation. In On Kawara's work we find a variation on this approach. He applies a printed legend to picture postcards from places he

visits ("I am still alive," "Today I got up at ..."). In this way he rescues a reflection of the act of living and preserves it in the static fixation of the work of art, while at the same time releasing, through the object character of the "work," a lasting product into the flow of life. Although a significant conceptual component is evident in the work of the latter-named artists, the boundaries between art and life are obscured.

Art and Life
Duchamp's Gioconda of 1965 alludes to the use of photo-text combinations by such figures as the Constructivists El Lissitzky, Rodchenko and Klucis, the Dadaists Schwitters, Hausmann and Heartfield, various Bauhaus artists and others beginning about 1920. In contrast to Duchamp's dual strategy, the works of these artists are oriented primarily to practical life and thus tend towards social engagement. Although these photographers produced many of their photographs themselves, they were interested only to a limited extent in photographic art. Their intended central focus was the educational, or appellative – if not agitative – character of these works. In their photo-texts the artists introduce the theme in basic terms through the photo; the text supplies an (often ironic) analysis or guidelines for action. The photo itself is deliberately assigned the function of communicating the impression that the event or scene in question really happened and is therefore true.[8]

To the extent that it challenges art to exercise a social influence and participate in the process of social restructuring, the work of art loses its autonomous character. In this sense, photo-texts become works of applied art. This line of development in art, which places a text alongside a photograph in order to aug-

[8] Roland Barthes, in the second part of *La chambre claire*, states that the essence of photography implies that what we see in a photograph was actually there at one time.

ment its "vague" pictorial messages with definite verbal statements, is evident again today, under altered contextual conditions, in the work of artists such as Klaus Staeck, Barbara Kruger and Jenny Holzer (much the same applies as well to such dissimilar artists as Beuys and Shirin Neshat). Quite a different approach is taken by the exponents of the Italian *Poesia Visiva* of the 1960s and early 1970s, whose representatives in the area of photo-text include Ketty La Rocca, Eugenio Miccini, Lamberto Pignotti and others. The emphasis here is usually on the verbal aspects of the work, into which pictorial and often photographic elements are integrated as complementary levels of expression.

Jenny Holzer explains why language plays such an important role for her: "From a political standpoint I was drawn to writing because it was possible to be very explicit about things."[9] Barbara Kruger also clearly appropriates advertising strategies, combining her memorable black-and-white pictures in the manner of the Russian Constructivists with appellative texts in red letters or on a red background. It seems natural that photo-text works of this type also take advantage of the possibility of reproduction that is built-in to the medium: works are created in multiple editions, in extreme cases as posters pasted up in public.

The methods employed by Duchamp and the early artists of the avant-garde are modified by contemporary artists, who alter the objects of translocation, but also their temporal contexts, accordingly. If art derives its meaning from the fact that it is concerned not only with innovation and the development of form within a hermetically sealed world of art but also addresses the reality of life under particular historical and social circumstances; if art is to be regarded as an articulation, perceptible by the senses, of the fears and wishes of people living at a particular time, as an instrument with which to search for meaning with the available resources of aesthetics; if art may (once again) and in fact should instruct and entertain and if it is truly the expression of the pleasure of play in the sense of Schiller's *homo ludens* – then the application of principles already discovered to altered situations is the newly articulated expression of the old necessity for people to find orientation, to attain self-assurance, to question their environment, to communicate, to express themselves "in play." It is worth noting that most artists' statements about themselves begin with the latter: with their irreducible need to act through art.

Andreas Hapkemeyer

[9] Jenny Holzer, *Buchstäblich*, p. 65.

Vincenzo Agnetti
Jean Le Gac
Peter Hutchinson
Joseph Beuys
Klaus Staeck
Urs Lüthi
Ken Lum
Duane Michals
Bernard Faucon
John Baldessari
Barbara Kruger
Gilbert & George
Marie-Jo Lafontaine
Jochen Gerz
Hamish Fulton
Olivier Richon
Jenny Holzer

Macchine drogate, 1969

Vincenzo Agnetti 15

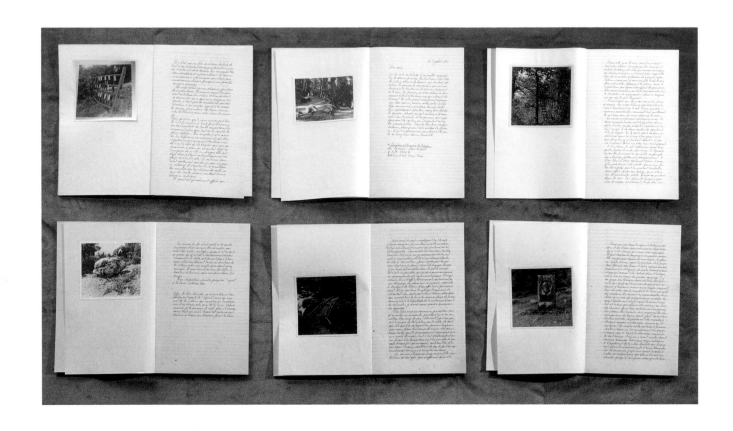

Les Cahiers (détail), 1968/71

16 **Jean Le Gac**

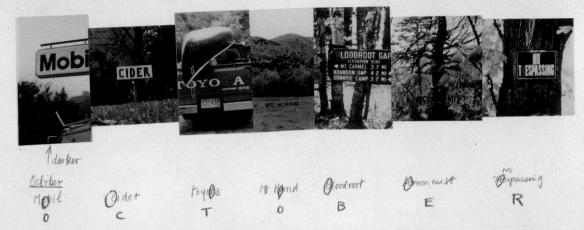

Working Drawing for "Year"
October

↑ darker

October
Mobil · Cider · Toyota · Mt Horrid · Bloodroot · lemon mist · no Trespassing
O · C · T · O · B · E · R

The signs of the waning year. Mobil, cider, Mt. Horrid, lemon mist. We walk through the high mountains and paddle down the slow river. Two nights and one day in a tent, trapped by the rain and hallucinating lights in the utter blackness. Lots of cropping. Stick on letters. The hardest piece to do. Signs can be perceptual or conceptual, real or imagined. Used ASA 16 slide film which turned out to be hard to print, although the slides showed good color.

Peter Hutchinson
October 1978

Working Drawing for "Year": October, 1978

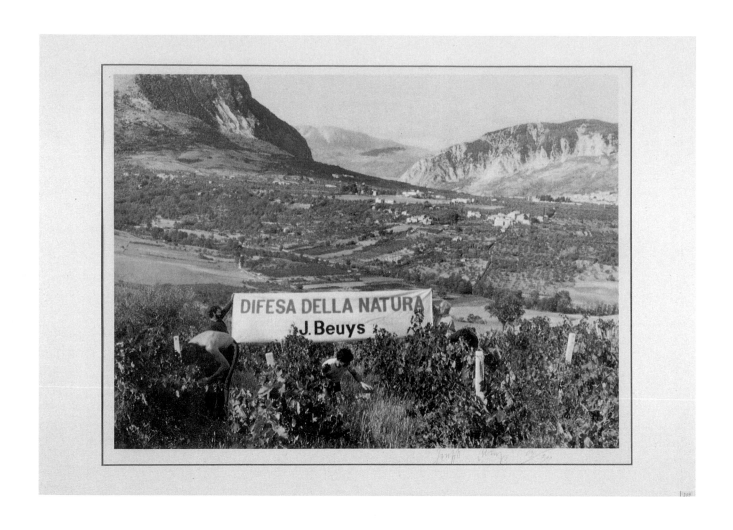

Difesa della natura, 1984

Joseph Beuys

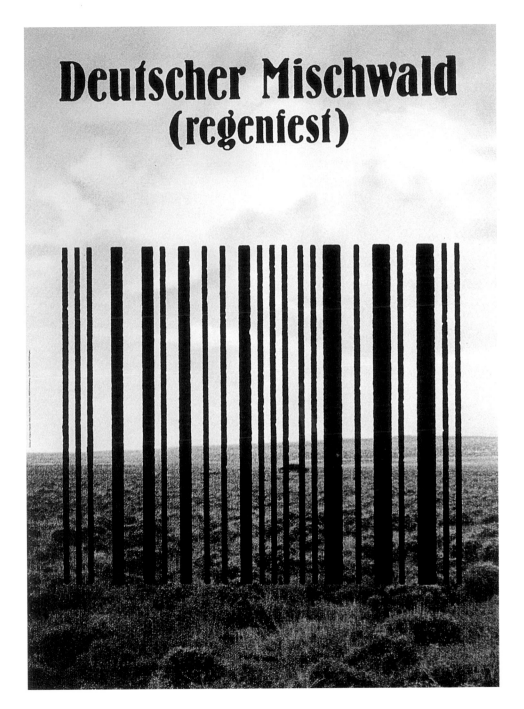

Deutscher Mischwald (regenfest), 1984

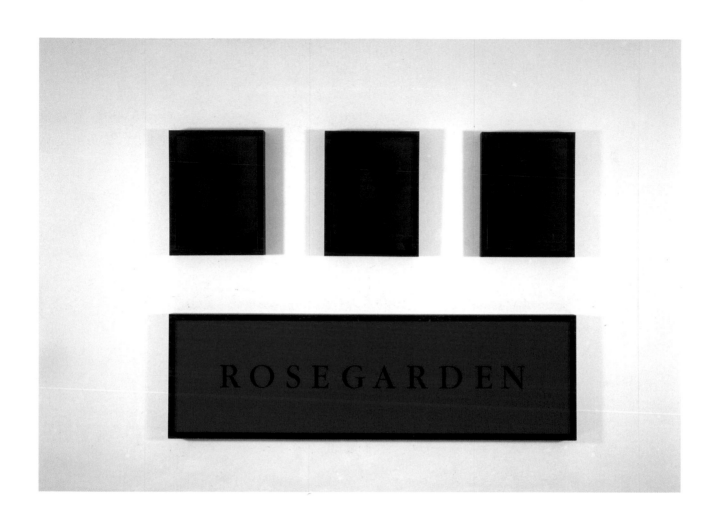

Rosegarden, 1989

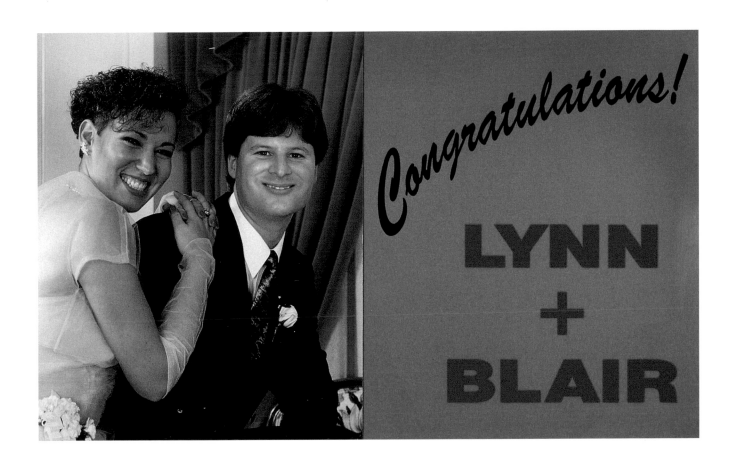

Congratulations! Lynn + Blair, 1989

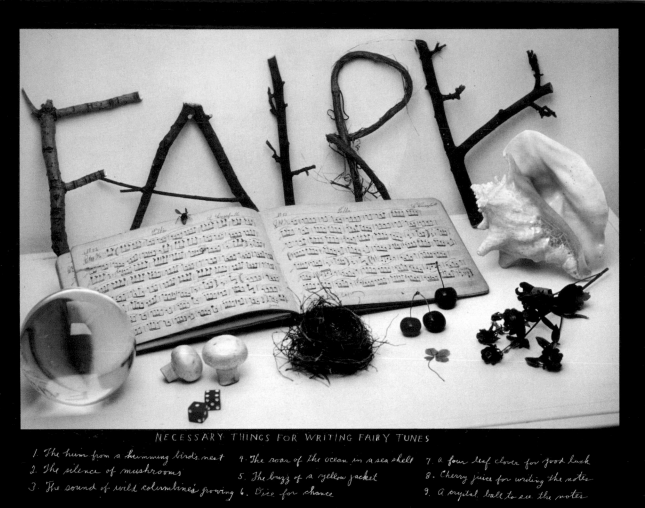

Necessary Things for Writing Fairy Tunes, 1989

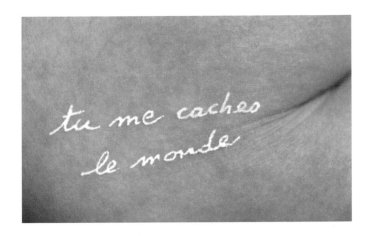

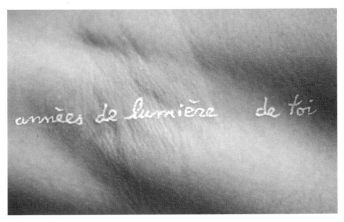

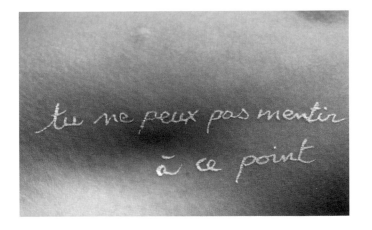

Tu me caches le monde, 1995 / Années de lumière de toi, 1995 / Tu ne peux pas mentir, à ce point, 1995

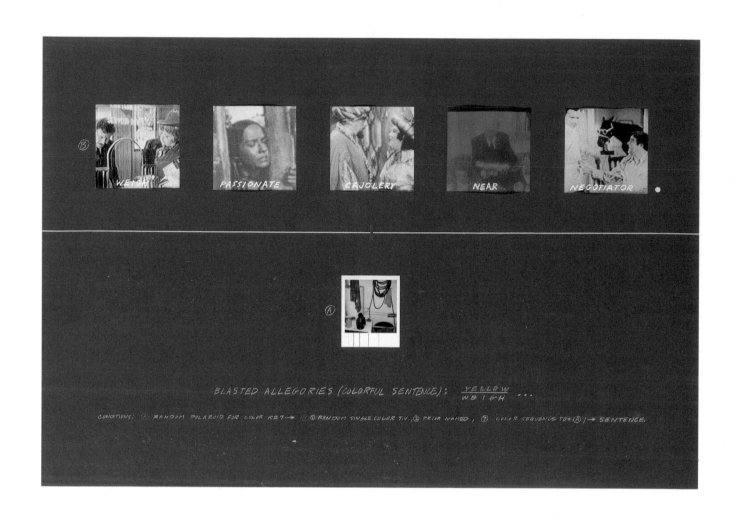

Blasted Allegories (Colorful Sentence): Yellow/Weigh ..., 1978

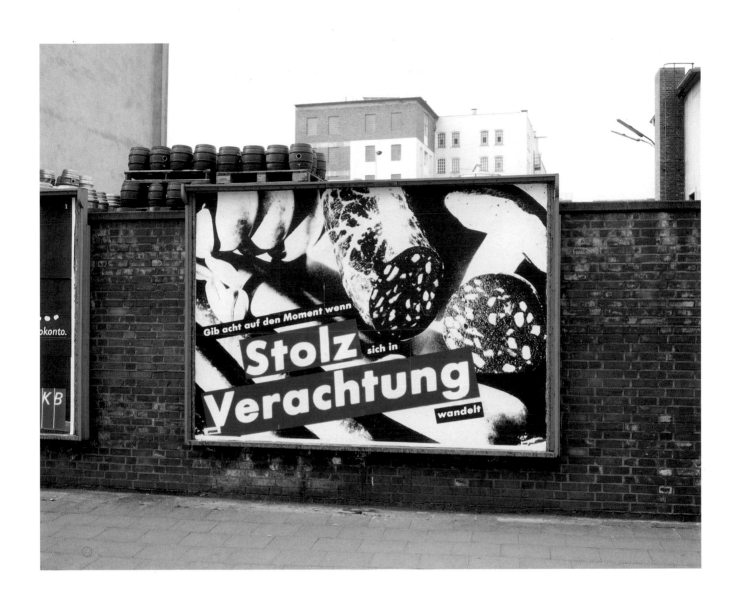

Gib acht auf den Moment, wenn Stolz sich in Verachtung wandelt, 1990

Barbara Kruger 25

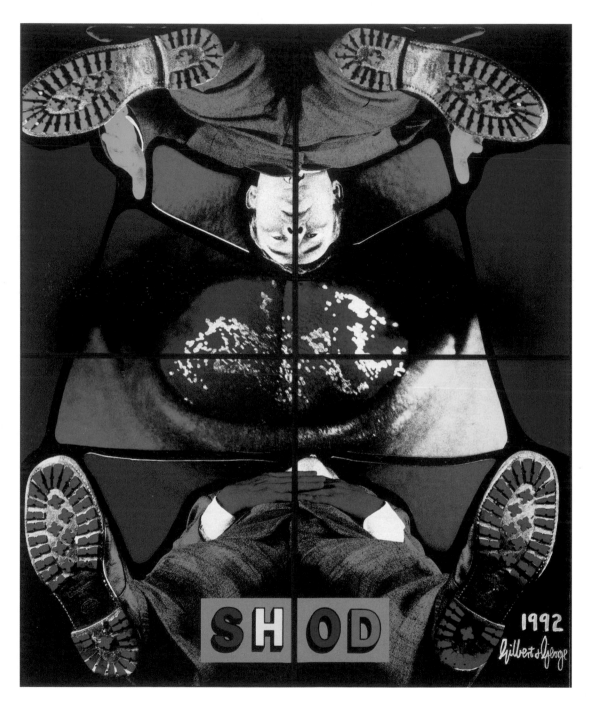

Shod, 1992

Argusauge, 1991

Marie-Jo Lafontaine 27

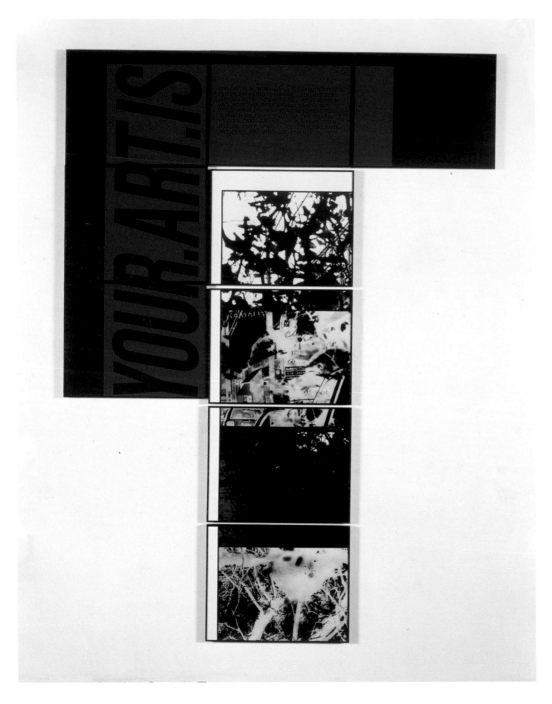

Your Art No. 6, 1991

Jochen Gerz

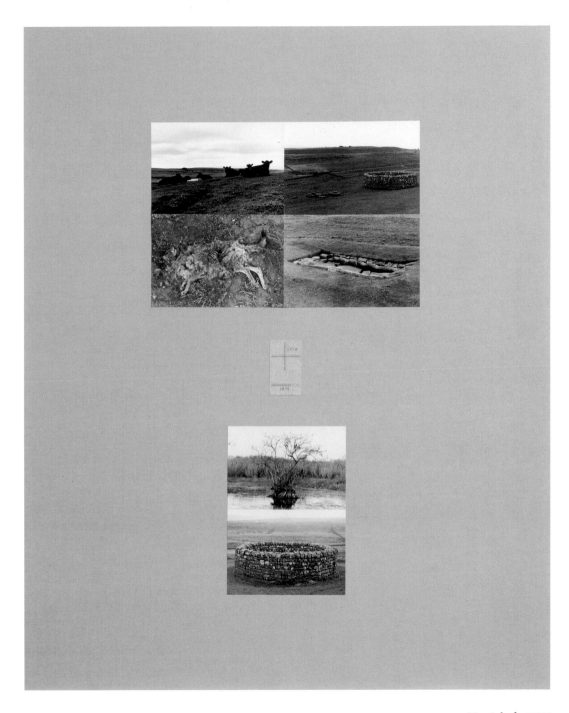

Untitled, 1971

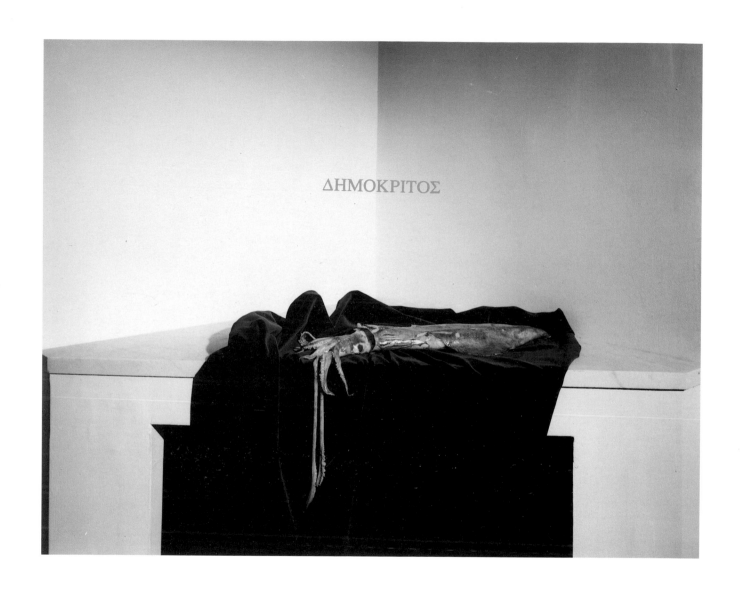

After D. L.: Demokritos, 1993

30 **Olivier Richon**

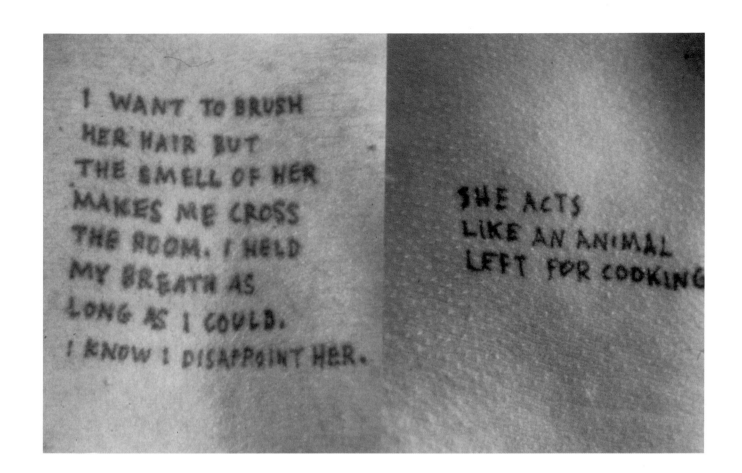

I WANT TO BRUSH
HER HAIR BUT
THE SMELL OF HER
MAKES ME CROSS
THE ROOM. I HELD
MY BREATH AS
LONG AS I COULD.
I KNOW I DISAPPOINT HER.

SHE ACTS
LIKE AN ANIMAL
LEFT FOR COOKING

Untitled, selections from "Lustmord", 1993/94

Jenny Holzer 31

Between Text and Photo

The decision to present this exhibition was based upon a number of considerations. On the one hand it seeks to document the wealth of aesthetic strategies applied to the simultaneous use of text and photography in art since the 1960s – the decade of the birth of Conceptual Art – and in so doing to focus upon those artists who have devoted the greater part of their efforts to such endeavors; on the other hand, this anthology attempts to define existing differences in historical terms – that is, to demonstrate that conceptual strategies with roots in the works of the radical Conceptual Artists today once again form an essential core segment of what is most interesting in contemporary practice.

In his book *Avant-Garde and After – Rethinking Art Now,* Brandon Taylor suggests that with its return to traditional media and markets the continued existence of an avant-garde after the 1980s appeared uncertain. However, he quite rightly confirms a return to Marcel Duchamp's philosophy of the ready-made during the past fifteen years and the presence of a continuity that is also a theme in our exhibition. "Art now turned back to the possibilities of the Duchampian ready-made (the found or encountered object); it proposed a dialogue about the concept and purpose of the photograph; and it declared a return to an openly narrative or story-telling method. Such concerns, which seemed suddenly beleaguered in the days of the painting revival, have come in the last fifteen or twenty years to constitute the best new art of our time."[1] The differences between the largely inexpressive works of Conceptual Art, based primarily on the respective sign and symbol systems inherent in the information itself, and today's art is readily evident. Beginning with an analytical interest in the individual linguistic systems that underlay the works and which they questioned, the theme of representation and the concept of art as an idea, the way has led to more complex narrative forms in which clear links are established to a reality communicated by the media, to a richer iconography and to a world of images with its origins in mass culture. Taylor calls this tendency "narrating identity," a term that has nothing to do with the collective term used to designate a group of international artists of the 1970s, represented in this exhibition by Peter Hutchinson, who combined images and textual narrative. Taylor responds to the diverse and not exclusively system-related concerns of contemporary artists when he states: "In calling this impulse narrative, I refer primarily to its embrace of imagery that originates in a mass culture, takes its connotations to the fields of bodily experience, personal and racial identity, and by importing 'meaning' directly occludes the strategies of the ready-made in most of its classic or recent forms. The most graphic contrast is with Duchampian art, which proposes a critique of ideas of art – institutional, authorial or managerial – by means of devices of art alone."[2] The connection between the symbolic language of print and photography as a presentation of reality is an old one. The dialogue quality so strikingly propagated in the exhibition title is already quite evident in the conventional captions of books and periodicals. As exhibition titles typically do, our title suggests a radically simplified matrix of references that does not, of course, apply to all areas. "photo text text photo"

[1] Brandon Taylor, *Avant-Garde and After – Rethinking Art Now* (New York, 1995), p. 10.
[2] *ibid.,* p. 143.

can be interpreted as a collocation of text and photography, but also as a hierarchical arrangement. A close examination of the selection of works shown in the exhibition clearly indicates the existence of a variety of methodical approaches.

The artists cite images and texts, working with the ability of language to evoke internal images and ideas and the possibility of converting images to verbal concepts. They are also aware of the particular property of the photographic image – the illusion of authenticity it produces and its ability to refer to actual reality, to be more concrete than abstract verbal language and its system of signs and symbols. Nevertheless, the artist also knows that reality is always perceived through the eye of a medium and affected by the intentions of those who record it. The artist considers the laws of the photographic image and takes into account the peculiarities of the printed word. We find in modern art mixed aesthetic forms that can be viewed as precursors. One such form, realized by Surrealists, Cubists and Dadaists alike, was the collage. A noteworthy precursor figure for artists like Klaus Staeck or Barbara Kruger was John Heartfield, whose critical, politically committed, didactic-enlightening art served an important model function. Artists of the middle, but predominantly of the youngest generation have concerned themselves with a wide range of diverse forms of text-and-image combinations. Various photographic typologies have also been examined. With respect to the amount of text used, the spectrum ranges from single words, such as those inscribed in the loud-colored, heraldic-allegorical photos, reminiscent of neo-Gothic church windows, of Gilbert & George, to the short hand-written narratives placed alongside the photographs of Duane Michals, from revolutionary appeals written across the photos of Joseph Beuys to often strict typographical arrangements whose typography (Ken Lum) permits immediate associations with their particular provenance.

The early works of Conceptual Art are much more modest in terms of the appearance and size of their typographical elements. The issue is one of information, the "dialectic process" of image and text that, as Douglas Huebler remarks in his statement, is the real subject of the work. With regard to the early works of Conceptual Art it should be remembered that these artists were intent upon placing themselves outside the context of galleries and museums, while the younger artists appear within the infrastructure of contemporary art to which they allude. The difference, in terms of size, presentation form, framing, etc., could hardly be greater. One might compare, for instance, the appearance of a work by Douglas Huebler with an opulently framed and installed piece by Marie-Jo Lafontaine.

The selection presented in our exhibition is meant to provide a survey. Thus Acconci's photos, with their choreographed look, represents the early Performance movement; Peter Hutchinson exemplifies "narrative art," a group of primarily American artists who combined a variety of narrative forms in photo-and-text stories. Karen Knorr speaks of a realm between text and image: "that creates a reflective space, inviting the beholder to linger on the captions, stories,legends, histories, photographs and texts both mutually independent and fully collaborative."[3] The linking of text and photo, she comments, enables us to see the boundary between text and image. The viewer wishes to create harmony between text and image in all of the works. While Maurizio Nannucci cites the clear concreteness of the word and the un-

[3] See the statement by Karen Knorr in the appendix, p. 134.

spoken feeling the image evokes, others stress the openness of both forms. Ken Lum suggests that text underscores the inability of the photograph to capture real experience, remarking that text produces its own image. He wants the photograph to generate a text of its own that is both related to and very different from the text provided. Thus each of his works represents a dual image. In the works of Laura Padgett, the eye wanders back and forth from the texts placed between the photos and the photos themselves, comparing the respective meanings – the "text" evoked by the photographs in the viewer and the "image" generated by the text.

For many artists, photography's function as a channel for personal, subjective expression is of little importance. With the exception of the work of Bernard Faucon and Duane Michals, most of the photographs tend towards anonymity or relate to particular formulas of commercial photography. Jochen Gerz articulates this in describing his own pictures as photos that could have been made by any number of different people – everyday pictures, technically unpretentious photographs.

In her simple, memorable combinations, Barbara Kruger, whose career spans both graphic design and commercial photography, employs billboard typography and pictorial material from commercial art. Similarly, John Baldessari has taken his stills from old Hollywood films.

Handwriting, as used very early on by Beuys or Ketty La Rocca, for example, or as it appears throughout the work of Duane Michals as a personal, identifiable script, is subjective and introduces the artist's own temporality and psycho-grammatical sensitivity into the picture.

In confronting certain works with one another the exhibition permits a precise examination of the artistic resources employed. Often, what appears similar at first glance reveals differences under more careful scrutiny. In the tradition of British landscape poetry, Hamish Fulton creates large-format photos of unpopulated virgin landscapes coupled with classical printed texts that ordinarily convey the provenance of the photograph as described in a program for a walking tour through the respective landscape. The abstract text representing the completed project is linked to the context of the work by the inclusion of a tiny detail from the actual natural reality depicted. Instead of retreating into a pre-modern past, Willie Doherty overwrites his Northern Irish landscapes with words (as Fulton does as well) that permit us to view the cultural text of the landscape in terms of its contradictory social, political and historical dimensions.

Bernard Faucon's leave-taking from the subjects of his photography does not lead to an abandonment of the medium but instead to photographed texts that describe previous experiences.

Duane Michals remarks in his statements that the artist should not be determined by his medium but should himself define the medium according to his own intentions.

The photographic image plays a role of central importance in our media age, and no less is true of texts and systems of signs and symbols. The artists are interested in the exploration of these systems, their interrelationships and their typological contents.

Peter Weiermair

Vito Acconci
Vincenzo Agnetti
John Baldessari
Robert Barry
Joseph Beuys
Heiner Blum
Victor Burgin
Willie Doherty
Bernard Faucon
Hamish Fulton
Jochen Gerz
Gilbert & George
Jenny Holzer
Douglas Huebler
Peter Hutchinson
On Kawara
Karen Knorr
Joseph Kosuth
Barbara Kruger
Ketty La Rocca
Marie-Jo Lafontaine
Louise Lawler
Jean Le Gac
Ken Lum
Urs Lüthi
Duane Michals
Maurizio Nannucci
Shirin Neshat
Laura Padgett
Giulio Paolini
Olivier Richon
Klaus Staeck

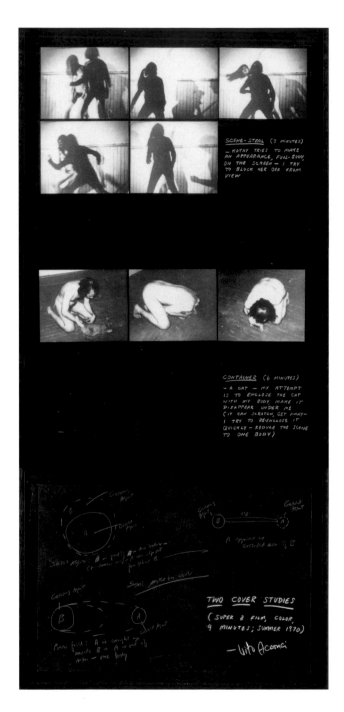

Two Cover Studies, 1976

Vito Acconci

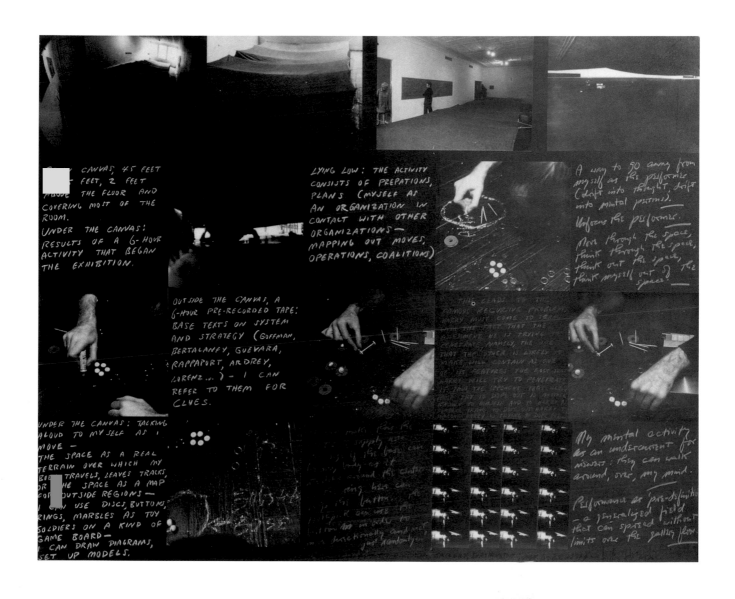

Drawing Ground, 1971

MD Ottobre, 1969

Le bandiere (Iran/Etiopia), 1970

Vincenzo Agnetti 41

One Thought (Yellow) and Scheming Man (Violet), 1989

42 **John Baldessari**

Jim with Green Frame and Black Words, 1992

Robert Barry 43

Icon (detail), 1975

44 **Robert Barry**

Icon (detail), 1975

Robert Barry 45

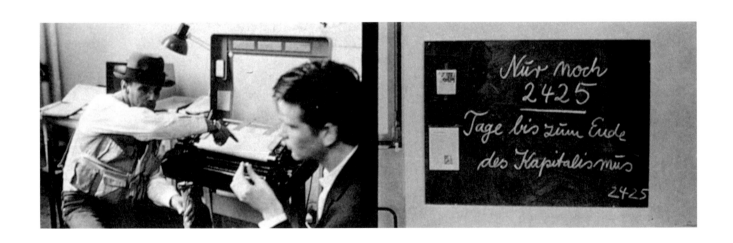

Nur noch 2425 Tage bis zum Ende des Kapitalismus, 1980

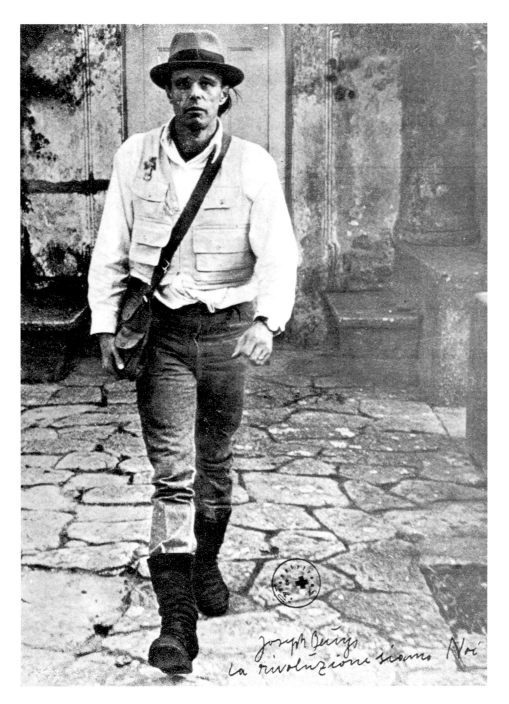

La rivoluzione siamo Noi, 1972

Joseph Beuys 47

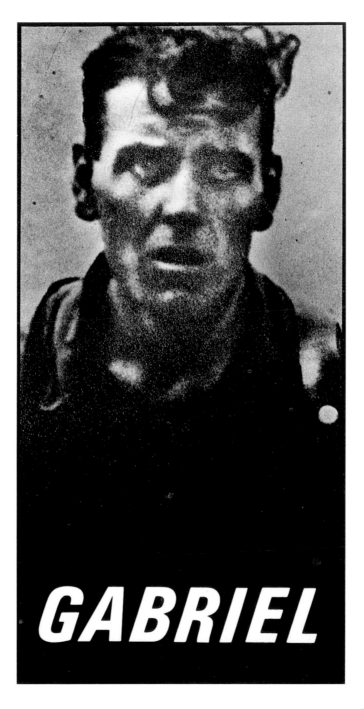

Ohne Titel (Erzengel), 1988

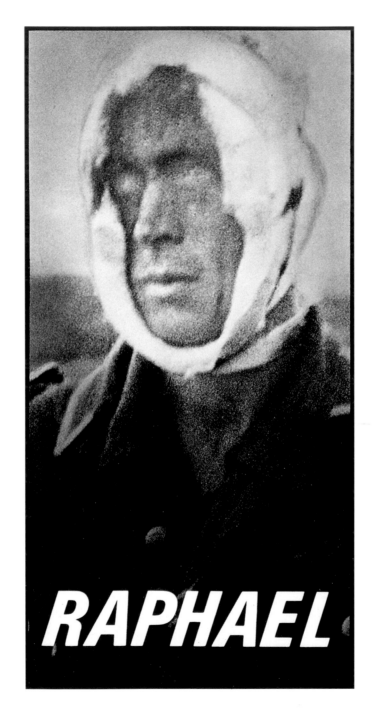

Ohne Titel (Erzengel), 1988

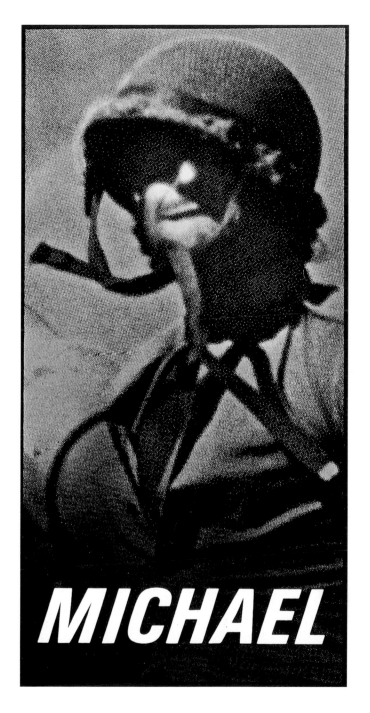

Ohne Titel (Erzengel), 1988

Olympia, 1982

Victor Burgin 53

Olympia, 1982

Olympia, 1982

Victor Burgin 55

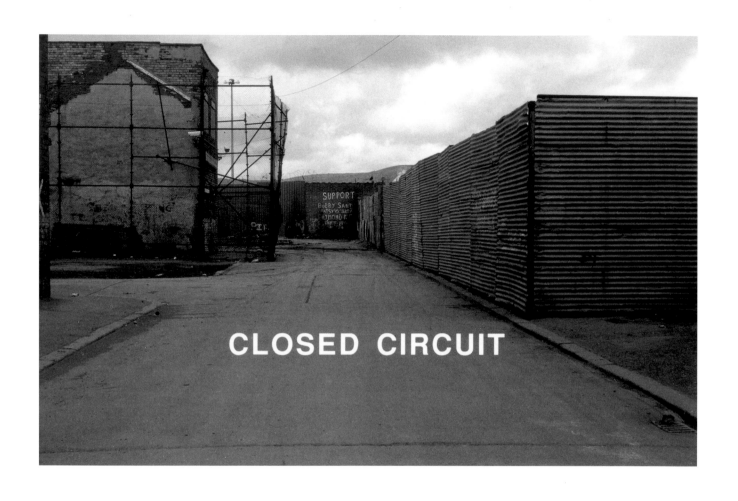

Closed Circuit, Sinn Fein Advice Centre, Short Strand, Belfast, 1989

56 **Willie Doherty**

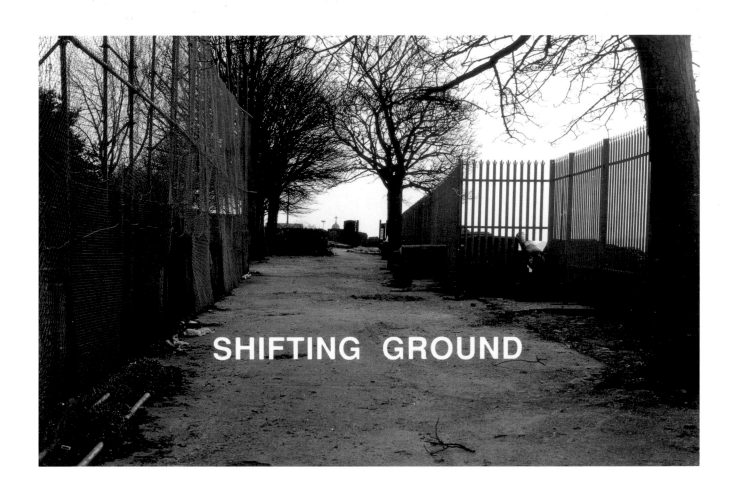

Shifting Ground, The Walls, Derry, 1991

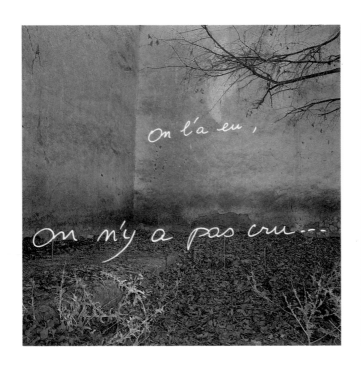 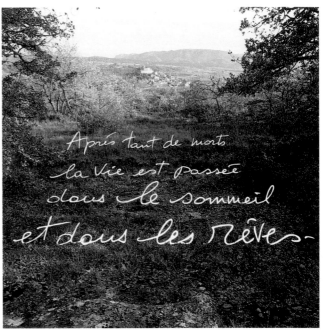

On l'a eu, on n'y a pas cru, 1991/92 / Après tant de morts la vie est passée ..., 1991/92

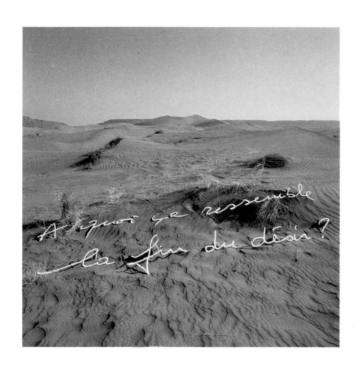 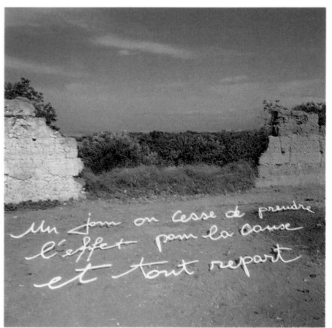

Ni ange, ni démon …, 1995 / Dernier trait d'union, dernier trait d'indulgence, 1995

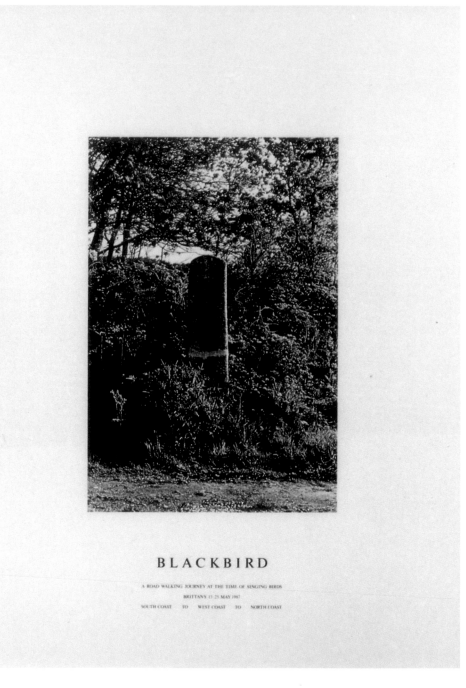

BLACKBIRD

A ROAD WALKING JOURNEY AT THE TIME OF SINGING BIRDS

BRITTANY 13-25 MAY 1987

SOUTH COAST TO WEST COAST TO NORTH COAST

Blackbird, 1987

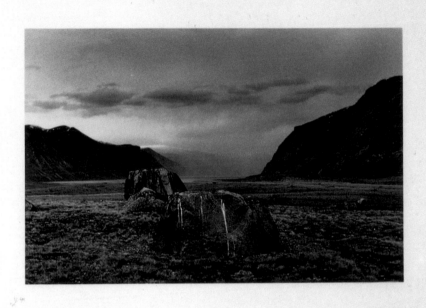

THE OWL RIVER VALLEY

The Owl River Valley, 1988

Hamish Fulton 61

Unter dem Vordach hatte sich Laub gesammelt. Die Türen standen halb offen. Sie mahnten an die Grabstatt, die C. sich nicht weit von hier errichten liess. Der Wunsch, sie zu schliessen, war ihm erst später gekommen, beim Anblick der Bilder. Den Weg zum Ausgang säumten ähnliche Häuser leer und mit längst verblichener Aufschrift.

Foto/Text 91, 1976/78

Jochen Gerz 63

Sagte der eine zum anderen Mann am Ende einer kleinen Reise: gleich was
herauskommt bei unserem Gespräch, ob am Ende der eine oder der andere seine
Meinung bestätigt sieht oder gar versucht ist, seine Ansicht einem der
Einheimischen hier mitzuteilen - gleich was dabei herauskommt, soweit wollen wir
es nicht kommen lassen. Als hätte uns beiden, sagte der andere, die Suche des
gleichen Gegenstands nicht genug Mühe gemacht. Ich möchte ihn nicht unter einer
Wolke aus Gold versinken sehen, denn dann wären wir ihn los und der Spass wäre
von kurzer Dauer. Sagte der erste: ich weiss, dass ich mich nicht als einen
Weitgereisten bezeichnen kann, aber lieber bin ich ein Wandersmann in der
Ferienzeit als ein Fragensteller oder, schlimmer, einer der auf Antwort hofft.

(Die Insel Abendwolke)

Die Insel Abendwolke, 1986

64 **Jochen Gerz**

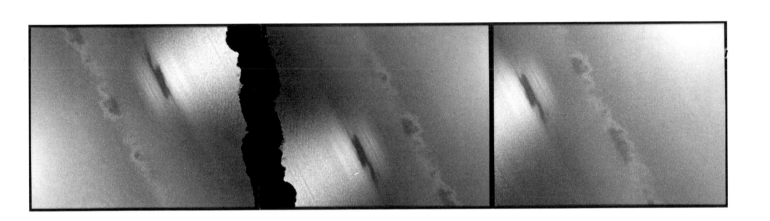

Die Insel Abendwolke, 1986

Jochen Gerz 65

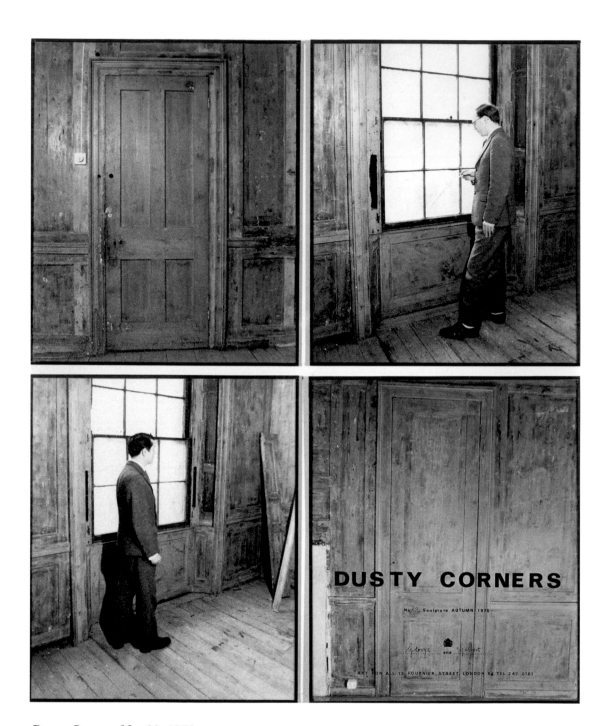

Dusty Corners No. 20, 1975

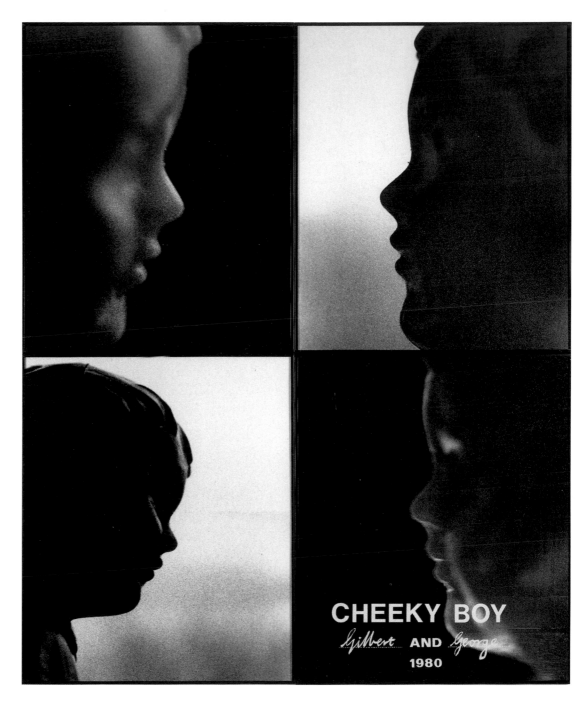

Cheeky Boy, 1980

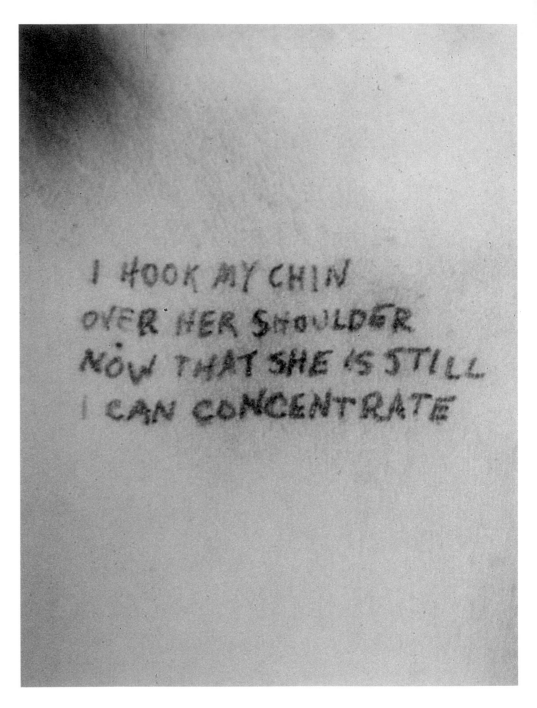

Untitled, selections from "Lustmord", 1993/94

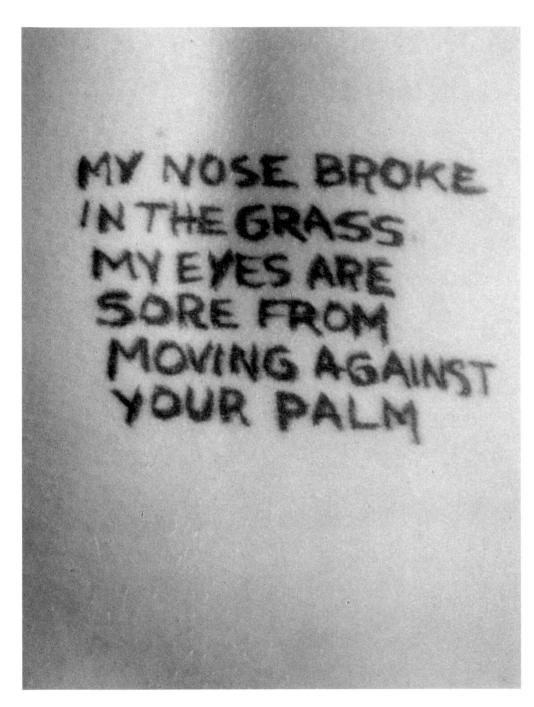

MY NOSE BROKE
IN THE GRASS.
MY EYES ARE
SORE FROM
MOVING AGAINST
YOUR PALM

Untitled, selections from "Lustmord", 1993/94

Jenny Holzer 69

Duration Piece No. 4, 1969

Douglas Huebler

Eight people were photographed at the instant exactly after each had been told: "You have a beautiful face", or, "You have a very special face", or, "You have a remarkable face", or in one instance, nothing at all. The artist knew only one person among the eight; it is not likely that he will ever again have a personal contact with any of the others.

Variable Piece No. 1A (detail), 1971

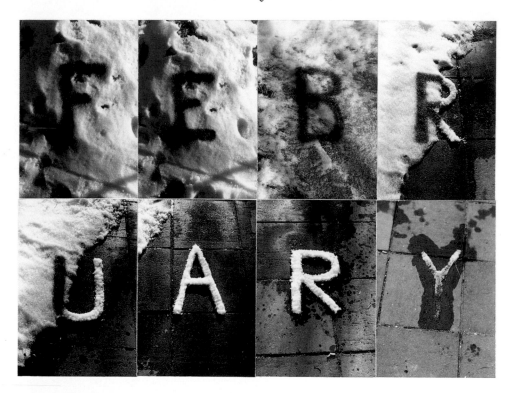

Working Drawing for "Year"
February

Snow is melting on the green concrete patio
At night it freezes again. Michael helps
me make letters with the snow. I use
green spray paint. "F" is green on white.
"Y" is white on green. Is the green appear-
ing or disappearing?

Peter Hutchinson
February 1978

Working Drawing for "Year": February, 1978

Working Drawing for "Year"
August

Asymmetrical. Exciting. Every day is sunny.
I have two drinks each afternoon and some
times play Frisbee, not too well. Black
skin to blonde. Young to old. His white
face means something. Couldn't find
Bruce to do a hand-stand on his skate-
board. Bright color. Clear focus. Much
action.

Peter Hutchinson
August 1928

Working Drawing for "Year": August, 1978

Peter Hutchinson 73

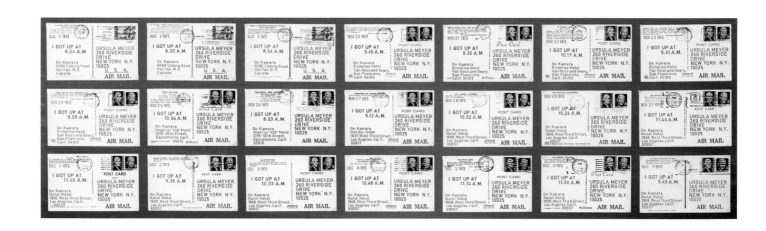

I got up at ..., 1973

I got up at ..., 1973

I live in the nineteenth century,
the early nineteenth century,
I am fascinated by
Napoleon and Metternich,
two antagonists.

Belgravia series (detail), 1979/81

I wouldn't vote
for any particular party
but rather for a
Leader.

Belgravia series (detail), 1979/81

78 **Karen Knorr**

If the Hostages in Iran
are released
Gold will plunge.

Belgravia series (detail), 1979/81

Karen Knorr 79

two, adj. *duo, bini* (= — each) ; a period of —
days, *biduum ;* a period of — years, *biennium :*
— -footed, † *bipes ;* —fold, *duplex ;* — -coloured,
† *bicolor ;* ---headed, *biceps ;* — -edged, *bipennis,*
— -handed, *duas manus habens ;* — hundred,
ducenti, duceni (= — hundred each). **twice,**
adv. *bis ;* — as much, *bis tantum ;* — as great,
altero parte major.

Two, 1967

blank [blæŋk] *a(dv)* blank, weiß, leer, ausdruckslos, offen; unbeschrieben; blanko . . .; bleich; blaß; reimlos; *s* Weiße *n*; leerer Raum *m*; Blankett *n*; Niete (Los) *f*; Schrötling (Metallstück) *m*; in ⌣ in blanco.

Blank, 1967

Joseph Kosuth

rul·er (rö′lėr), *n*. A strip of wood, metal, or other material with a straight edge, used in drawing lines, etc.; also, one who or that which rules paper, etc.; also, one who or that which rules or governs; a sovereign.

Ruler, 1965

Joseph Kosuth 83

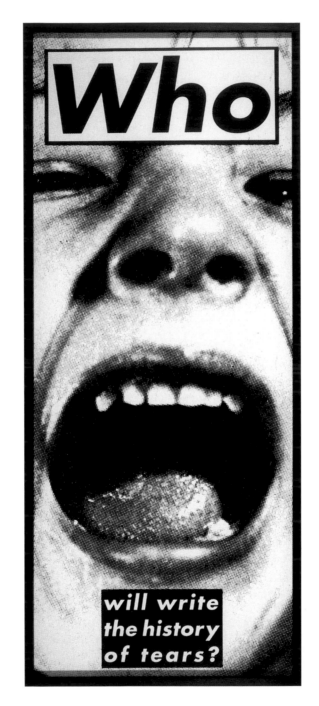

Who will write the history of tears? 1987

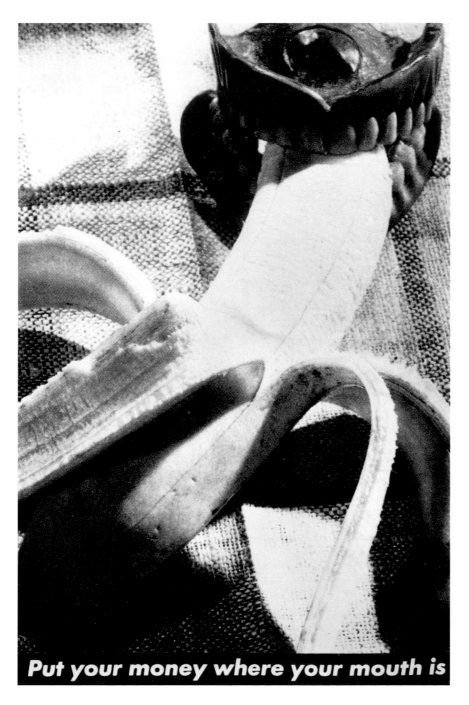

Untitled (Put your money where your mouth is), 1984

Un satiro, 1974

Un satiro, 1974

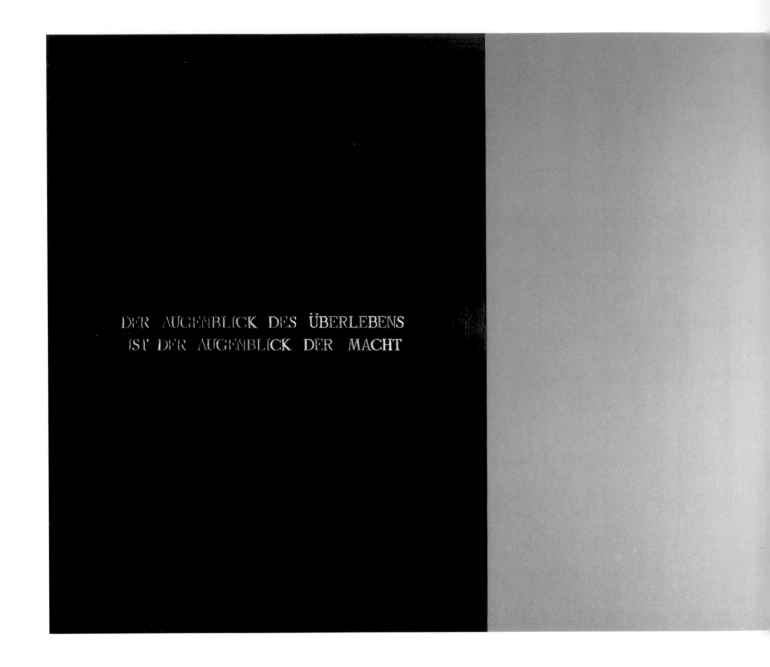

Der Augenblick des Überlebens ..., 1989

Der Augenblick des Überlebens ..., 1989

Marie-Jo Lafontaine 89

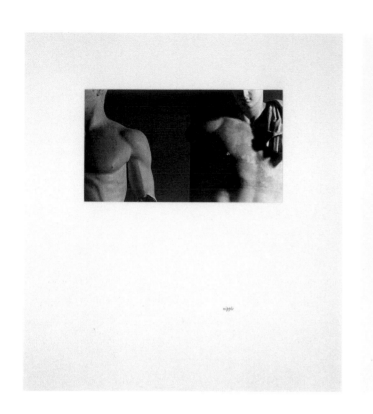

Nipple, 1984/93

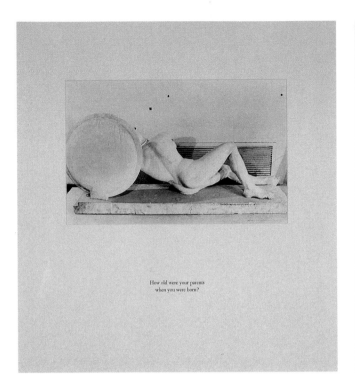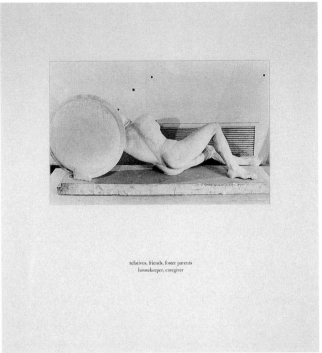

As of Yet Untitled, 1984/92

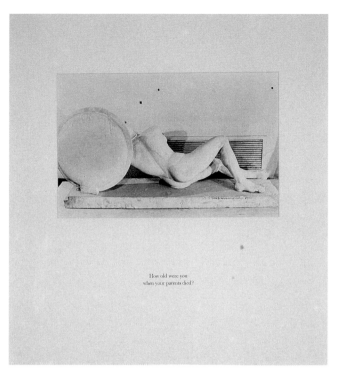

How old were you
when your parents died?

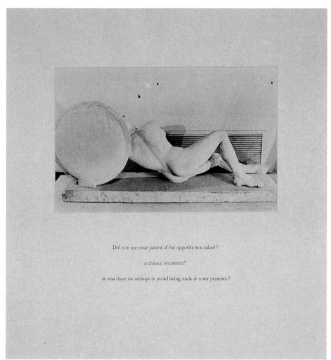

Did you see your parent of the opposite sex naked?

a chance occurence?

or was there no attempt to avoid being nude in your presence?

As of Yet Untitled, 1984/92

Louise Lawler 93

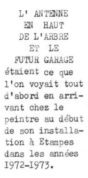

L' ANTENNE
EN HAUT
DE L'ARBRE
ET LE
FUTUR GARAGE
étaient ce que
l'on voyait tout
d'abord en arri-
vant chez le
peintre au début
de son installa-
tion à Etampes
dans les années
1972-1973.

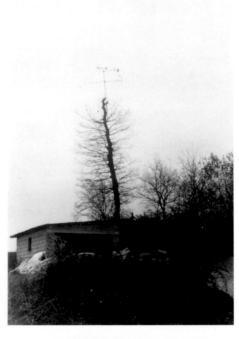

L'INFERNALE ZONE INDUSTRIELLE EN AVAL DE ROUEN
Entre les voies l'endroît où le peintre fut mêlé
à des évènements d'un ordre particulier n'ayant
rien à voir avec l'art et qui,bien que personne
en définitive ne portât plainte contre lui,contri-
buèrent à assombrir cette période de sa vie.
Il ne reviendra à l'art que dans les années 70.

FRONTISPICE DE : "LE PEINTRE AUX SCABIEUSES",
le meilleur ouvrage consacré à l'artiste.
"... J'étais très jeune et prêt à être impressionné
durablement par n'importe quelle forme d'art quand
le hasard me fit passer devant la vitrine d'un mar-
chand de tableaux."

Le peintre aux scabieuses, 1977

UN PEINTRE PHOTOGRAPHE !
Cette unique photo prise par le peintre au cours
d'un long voyage devait beaucoup amuser les siens
quand la précieuse pellicule une fois développée
fut découverte presque vierge !

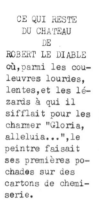

CE QUI RESTE
DU CHATEAU
DE
ROBERT LE DIABLE
où, parmi les cou-
leuvres lourdes,
lentes, et les lé-
zards à qui il
sifflait pour les
charmer "Gloria,
alleluia...", le
peintre faisait
ses premières po-
chades sur des
cartons de chemi-
serie.

LA MARE PAR TEMPS DE NEIGE(Photo conservée par la famille)
C'est là, qu'une nuit, ils virent au moment de la pon-
te une telle procession de crapauds que le peintre
plein de répugnance, voulant quand même franchir l'
obstacle à grandes embardées, vit le jeune Storge
descendre de la voiture et comme un petit démon, é-
carter du chemin à pleines mains les étrons vivants.

LE CHEMIN DES DOUANIERS QUI DOMINE
L'ANSE DE TREGUEZ (Finistère)
où à l'âge de quatre ans on retrouva tout en
sang le peintre, grimpé sur un banc, terrorisé
par d'hypothétiques lions !

VU DES REMPARTS L'ETAT ACTUEL DU JARDINET
Le 6 avril 1951 c'est de cet endroit, qu'assis les
pieds dans le vide et dessinant sur un carnet ce
qu'ils appelaient "Les Etranges Figures du Jardin
Roques", qu'un camarade de lycée du peintre tomba
accidentellement et se tua.

Le peintre aux scabieuses, 1977

Der Kunstprofessor, 1992

DER
KUNST
PROFESSOR

Der Kunstprofessor, 1992

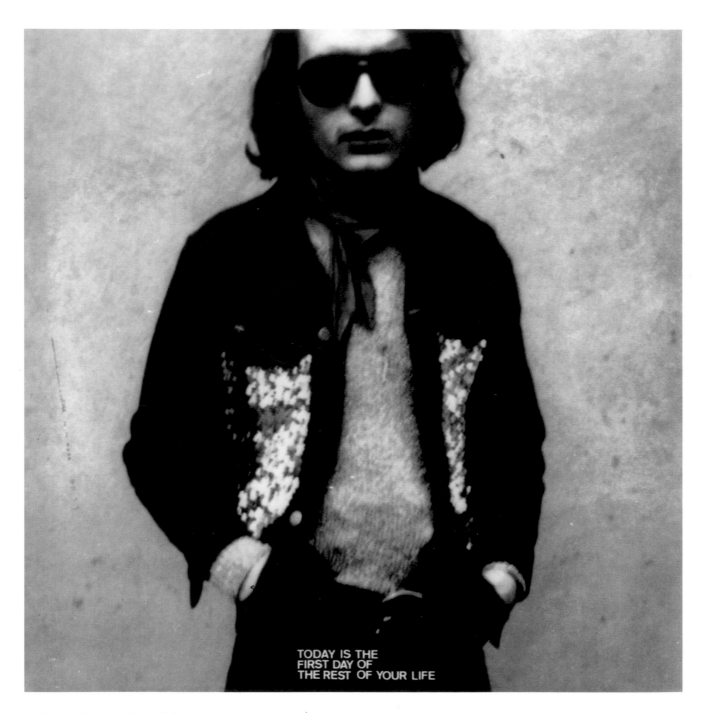

Today is the first day of the rest of your life, 1972

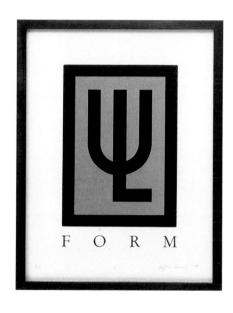 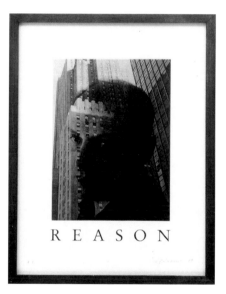 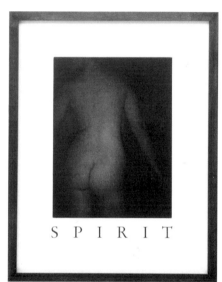

Form – Reason – Spirit, 1989

Urs Lüthi 99

A LETTER FROM MY FATHER

As long as I can remember, my father always said to me, that one day
he would write me a very special letter. But he never told me what the
letter might be about. I used to guess what I might read in the letter, what
mystery, what family secret might be revealed, what intimacy we might

share. I know what I had hoped to read in the letter. I wanted him to
tell me where he had hidden his affections. But then he died, and the
letter never did arrive, and I never found that place where he had
hidden his love.

A Letter From My Father, 1960/75

100 **Duane Michals**

SARAJEVO

In Sarajevo there's a mountain of meat, made of dead people unfit to eat.
With each hour this mountain grows higher, and it towers toward the sun,
where its shadow falls on everyone, not just those whose lives are done.
For all who cower in this grim shade, dread descends as light fades.
Now where children once played, only their shadows remain.
Innocence soon learns that there is no defense against its foes and our faux concerns.
When all prayers fail, there is no heaven only hell.
Where the savage self prevails, hope rots in the carcus of the city.
What good is our polite pity?
Why should we care, when we are here and they are there?

Duane Michals 1/23

Sarajevo, 1994

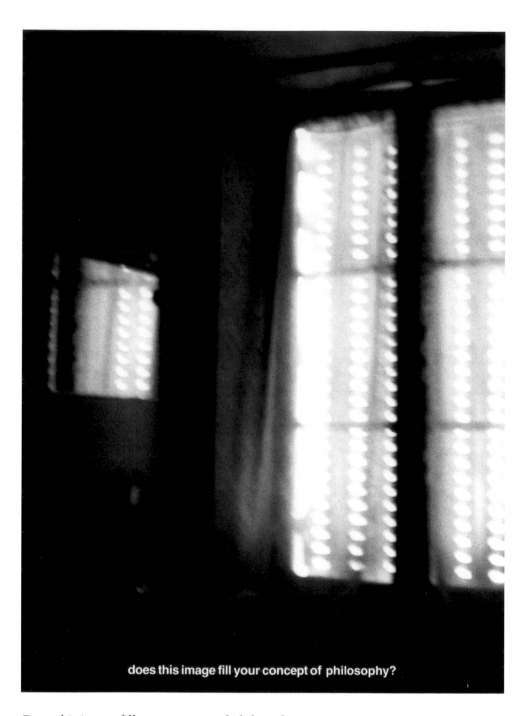

Does this image fill your concept of philosophy? 1976

102 **Maurizio Nannucci**

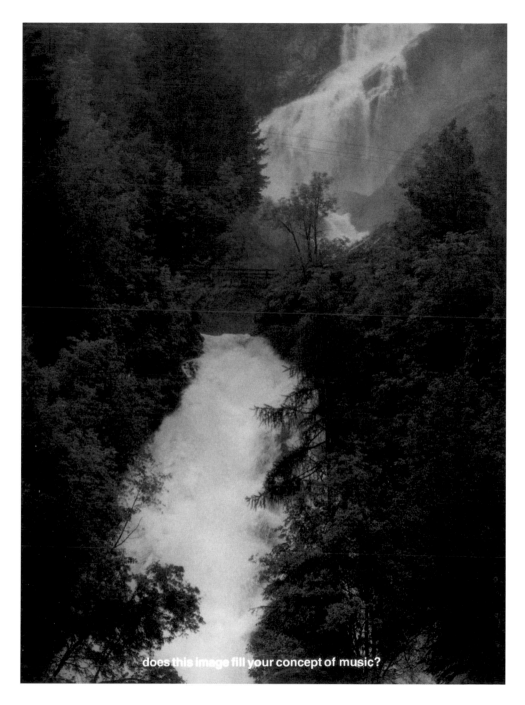

Does this image fill your concept of music? 1976

Maurizio Nannucci 103

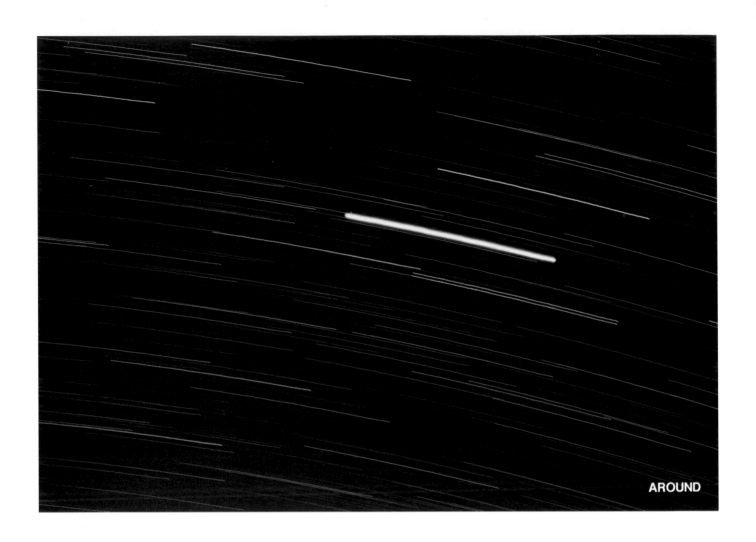

Moving Stars, 1969

104 **Maurizio Nannucci**

Moving Stars, 1969

Maurizio Nannucci 105

Offered Eyes, 1993

Grace Under Duty, 1994

108 **Shirin Neshat**

Rebellious Silence, 1994

Shirin Neshat 109

coming back

a piece broke off It happened

again. I brought something with me.

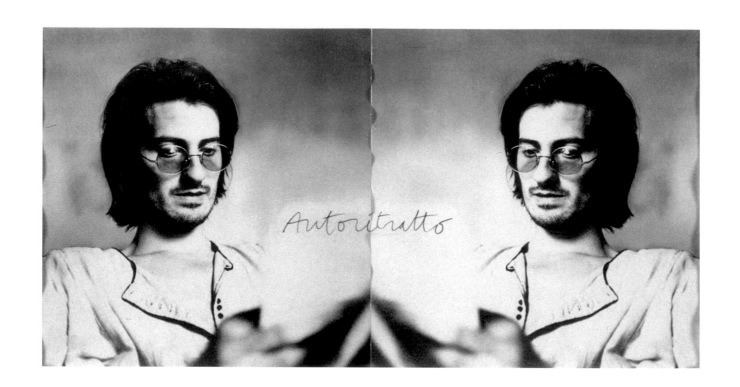

Autoritratto, 1970

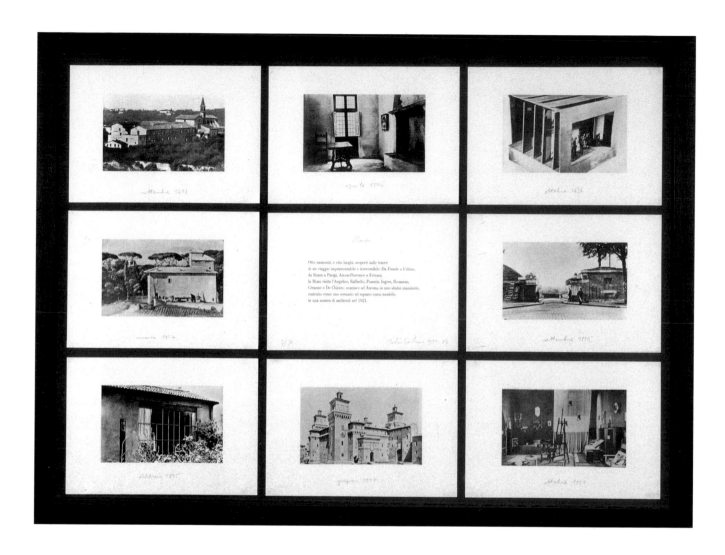

Museo, 1970/73

Giulio Paolini 115

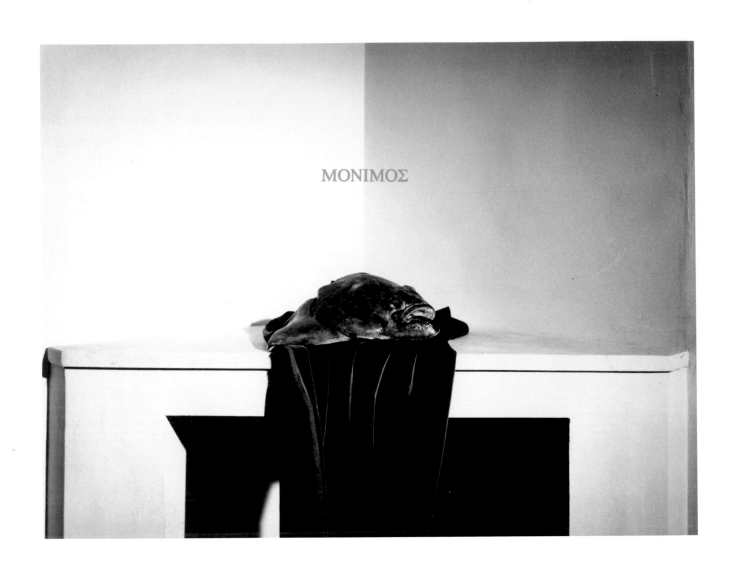

After D. L.: Monimos, 1993

116 **Olivier Richon**

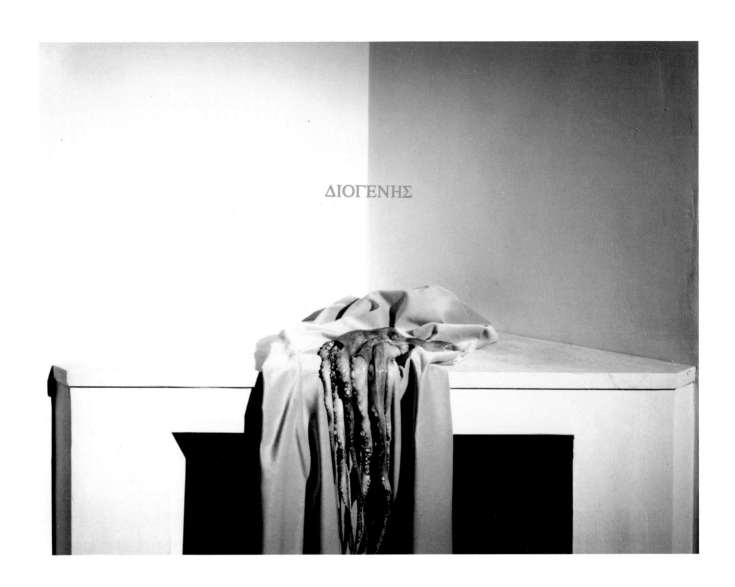

After D. L.: Diogenes, 1993

Olivier Richon 117

Die Kunst der 70er Jahre findet nicht im Saale statt

10. Mai 1974, 14.25 Uhr Athen Platz der Verfassung Geheimpolizisten haben den Kölner Schriftsteller und Journalisten Günther Wallraff während einer Flugblattaktion zu Boden ge- schlagen. Sein Gesicht ist völlig zugeschwollen. Er blutet aus einer klaffenden Wunde am Hinterkopf.

Beitrag Klaus Staeck für Projekt '74 Kunsthalle Köln

Die Kunst der 70er Jahre findet nicht im Saale statt, 1974

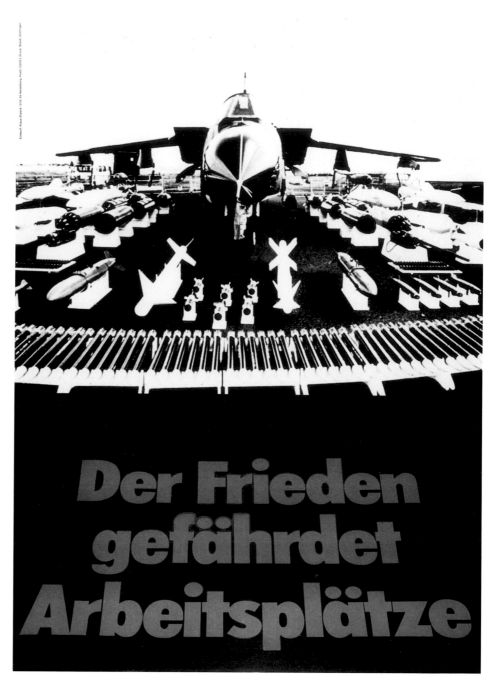

Der Frieden gefährdet Arbeitsplätze, 1978

List of Works

Vito Acconci
38
Two Cover Studies, 1976
Photograph, text
3 parts, each 51 x 76 cm

39
Drawing Ground, 1971
Photograph, collage
81 x 101 cm

Vincenzo Agnetti
15
Macchine drogate, 1969
Color photograph
40 x 40 cm

40
MD Ottobre, 1969
Photograph, text
51.5 x 71.5 cm

41
Le bandiere (Iran/Etiopia), 1970
2 parts, color photographs
Each 120 x 30 cm

John Baldessari
24
Blasted Allegories (Colorful Sentence):
Yellow/Weigh ..., 1978
C-type prints, polaroid, cardboard,
colored pencil
71 x 102 cm

42
One Thought (Yellow) and Scheming
Man (Violet), 1989
Photograph, oil, vinyl
151 x 60 cm

Robert Barry
43
Jim with Green Frame and Black Words,
1992
Ink and acrylic on photograph
66 x 66 cm

44–45
Icon (detail), 1975
80 slides with texts, projections

Joseph Beuys
18
Difesa della natura, 1984
Offset print
60 x 82 cm

46
Nur noch 2425 Tage bis zum Ende
des Kapitalismus, 1980
Offset print, cardboard
68.5 x 48.5 cm

47
La rivoluzione siamo Noi, 1972
Offset print on polyester foil
190 x 100 cm

Heiner Blum
49–51
Ohne Titel (Erzengel), 1988
Silver-bromide photograph
3 parts, each 225 x 113 x 5 cm

Victor Burgin
53–55
Olympia, 1982
6 photographs, text
Each 50 x 60 cm

Willie Doherty
56
Closed Circuit, Sinn Fein Advice
Centre, Short Strand, Belfast, 1989
B/W photograph, text
122 x 183 cm

57
Shifting Ground, The Walls, Derry,
1991
B/W photograph, text
122 x 183 cm

Bernard Faucon
23
Tu me caches le monde, 1995
Color photograph
18 x 23 cm

Années de lumière de toi, 1995
Color photograph
18 x 23 cm

Tu ne peux pas mentir, à ce point, 1995
Color photograph
18 x 23 cm

58
On l'a eu, on n'y a pas cru, 1991/92
Tirage Fresson on photo paper
60 x 60 cm

Après tant de morts la vie est passée …,
1991/92
Tirage Fresson on photo paper
60 x 60 cm

59
Ni ange, ni démon …, 1995
Color photograph
18 x 23 cm

Dernier trait d'union, dernier trait
d'indulgence, 1995
Color photograph
18 x 23 cm

Hamish Fulton
29
Untitled, 1971
Photograph, text
50 x 60 cm

60
Blackbird, 1987
B/W photograph, text
145 x 115 cm

61
The Owl River Valley, 1988
B/W photograph, text
119 x 142 cm

Jochen Gerz
28
Your Art No. 6, 1991
Photograph, text
200 x 150 cm

63
Foto/Text 91, 1976/78
B/W photographs, text
3 photographs, each 17 x 13 cm,
Text 17 x 9 cm

64–65
Die Insel Abendwolke, 1986
4 b/w photographs, 1 text
Each 40 x 50 cm

Gilbert & George
26
Shod, 1992
4 photographs
169 x 142 cm

66
Dusty Corners No. 20, 1975
4 photographs
122 x 102 cm

67
Cheeky Boy, 1980
4 b/w photographs
121 x 100 cm

Jenny Holzer
31, 68–69
Untitled, selections from "Lustmord,"
1993/94
C-print on aluminum
14 Cibachrome photographs,
Each 33.5 x 20 cm

Douglas Huebler
70
Duration Piece No. 4, 1969
Photographs, text
70 x 100 cm

71
Variable Piece No. 1A, The Netherlands,
United States, Italy, France and
Germany (detail), 1971
8 photographs, text
Photographs, each 20.3 x 25.4 cm,
Text 21.6 x 27.9 cm

Peter Hutchinson
17, 72–73
Working Drawing for "Year,"
January – December: October,
February, August, 1978
Photographs, text
12 parts, each 38.5 x 50 cm

On Kawara
74–75
I got up at …, 1973
Picture postcards with handwriting
21 parts, each 8.9 x 14 cm

Karen Knorr
77
I live in the nineteenth century …,
Belgravia series (detail), 1979/81
B/W photograph, text
41.5 x 52.5 cm

78
I wouldn't vote …,
Belgravia series (detail), 1979/81
B/W photograph, text
41.5 x 52.5 cm

79
If the Hostages in Iran …,
Belgravia series (detail), 1979/81
B/W photograph, text
41.5 x 52.5 cm

Joseph Kosuth
81
Two, 1967
B/W photograph on aluminum
120 x 120 cm

82
Blank, 1967
B/W photograph
125 x 125 cm

83
One and Three Objects. Ruler, 1967
Photograph, ruler, text
120 x 125 cm

Barbara Kruger
25
Gib acht auf den Moment, wenn Stolz
sich in Verachtung wandelt, 1990
Poster
244 x 360 cm, 8 parts, each 127 x 90 cm

84
Who will write the history of tears?
1987
Photograph
246.5 x 104.4 cm

85
Untitled (Put your money where
your mouth is), 1984
Photograph
182 x 121 cm

Ketty La Rocca
86–87
Un satiro, 1974
Ink on photograph
6 parts, each 17.7 x 12.7 cm

Marie-Jo Lafontaine
27
Argusauge, 1991
100 color photographs, text
Installation Glyptothek, Munich

88–89
Der Augenblick des Überlebens …, 1989
Acrylic, wood, photograph, brass
4 parts, 160 x 380 cm

Louise Lawler
91
Nipple, 1984/93
2 b/w photographs
Each 28 x 32 cm

92–93
As of Yet Untitled, 1984/92
4 b/w photographs
Each 49 x 45.5 cm

Jean Le Gac
16
Les Cahiers (détail), 1968/71
26 notebooks, 31 photographs
Notebooks, each 29.7 x 39 cm

94–95
Le peintre aux scabieuses, 1977
8 parts, photographs, text
Each 85.5 x 85.8 cm

Ken Lum
21
Congratulations! Lynn + Blair, 1989
C-print on acrylic
125 x 200 x 5.3 cm

96–97
Der Kunstprofessor, 1992
C-print, enamel, aluminum on Forex
120 x 275 cm

Urs Lüthi
20
Rosegarden, 1989
Acrylic, plexiglass
3 parts, two 78 x 58 cm, one 78 x 258 cm

98
Today is the first day of the rest
of your life, 1972
Color print, paper
61 x 61 cm

99
Form – Reason – Spirit, 1989
Photo engraving, aquatint,
silk-screen print
3 parts, each 55 x 42 cm

Duane Michals
22
Necessary Things for Writing
Fairy Tunes, 1989
Cibachrome, ink
16 x 20 cm

100
A Letter From My Father, 1960/75
Gelatin-silver print, ink
11 x 14 cm

101
Sarajevo, 1994
Gelatin-silver print, ink
16 x 20 cm

Maurizio Nannucci
102
Does this image fill your concept
of philosophy? 1976
Photograph
180 x 120 cm

103
Does this image fill your concept
of music? 1976
Photograph
180 x 120 cm

104–105
Moving Stars, 1969
2 parts, photographs on aluminum
Each 320 x 110 cm

Shirin Neshat
107
Offered Eyes, 1993
Gelatin-silver print
101.6 x 152.4 cm

108
Grace Under Duty, 1994
Gelatin-silver print
101.6 x 152.4 cm

109
Rebellious Silence, 1994
Gelatin-silver print
101.6 x 152.4 cm

Laura Padgett
111–113
Coming Back, 1996
B/W photographs on aluminum plates,
4 texts on self-adhesive foil
5 photographs, each 41 x 59.5 cm

Giulio Paolini
114
Autoritratto, 1970
Photograph
70 x 50 cm

115
Museo, 1970/73
8 photographs, 1 text
Each 25 x 35 cm

Olivier Richon
30
After D. L.: Demokritos, 1993
C-type color print
110 x 132. 5 cm

116
After D. L.: Monimos, 1993
C-type color print
110 x 132.5 cm

117
After D. L.: Diogenes, 1993
C-type color print
110 x 132. 5 cm

Klaus Staeck
19
Deutscher Mischwald (regenfest), 1984
Offset print
84 x 59 cm

118
Die Kunst der 70er Jahre findet nicht
im Saale statt, 1974
Offset print
84 x 59 cm

119
Der Frieden gefährdet Arbeitsplätze,
1978
Offset print
84 x 59 cm

Biographies
Bibliographies
Artists' Statements

The following entries are limited to essential biographical information and, with a few notable exceptions, listings of solo exhibitions for the period 1990–1996. The bibliography has been limited to a single reference for each artist.

The artist's statements include both original commentaries written specifically for this publication and reprinted textual materials related to the theme of the exhibition.

VITO ACCONCI

1940 Born in New York, where he now lives and works.

Solo exhibitions
1990 James Corcoran Gallery, New York
 Vito Acconci: Graphic Retrospective, Landfall Press, New York
1991 MAGASIN, Centre National d'Art Contemporain, Grenoble
 Barbara Gladstone Gallery, New York
 Galerie Anne de Villepoix, Paris
1992 Museo d'Arte Contemporanea Luigi Pecci, Prato
1993 Barbara Gladstone Gallery, New York
 Stroom, Haags Centrum Voor Beeldende Kunst, The Hague
 Vito Acconci: The City Inside Us, MAK – Museum für Angewandte Kunst, Vienna
 303 Gallery, New York
 Anne de Villepoix, Paris
 Monika Sprüth Galerie, Cologne
1994 Le Consortium, Centre d'Art Contemporain, Dijon
 A Graphic Retrospective, University of Missouri / Kansas, City Gallery of Art, Kansas City
 Musée d'Art Moderne, St. Etienne
1995 *Theater Project for a Rock Band* (in collaboration with The Mekons), Dia Center for the Arts/BAM Visual Arts Initiative, New York

Bibl. *Vito Acconci,* MAK – Museum für Angewandte Kunst, Vienna, 1993.

Statement

Before I did work in an art context, I was writing poetry. My first pieces, in an art-context, were activities in the street; this excursion into the street could be seen as an attempt to leave home, a home shaped by the contact of writing-person and desktop, through means of paper and pen and defined by the boundaries of light. The sheet of paper, looked down at on a desk, was analogous to the plan-view of a house; going out into the street was a way of literally breaking the margins, breaking out of the house and leaving the paper behind. After a few months of doing street pieces, however, I started doing pieces with my own body: I concentrated on myself, I worked on my own person. It was as if I had left home too quickly, as if I was afraid I would be lost out in the streets: I had to come back home – whatever work I would do in an art-context had to begin with what I could assume I knew at least something about (had to begin with my own body, had to begin at home).

(from: Vito Acconci, *Projections of Home,* Museo d'Arte Contemporanea Luigi Pecci, Prato, January 1988.)

VINCENZO AGNETTI

1926 Born in Milan. Exhibited at the Biennial in Venice in 1974, 1976, 1978 and 1980. Died in Milan in 1981.

Solo exhibitions
1967 *Principia,* Palazzo dei Diamanti, Ferrara
1968 *La macchina drogata,* Galleria Visualità, Milan
1969 *Oltre il linguaggio,* Galleria Visualità, Milan
1970 *Assiomi,* Galleria Blu, Milan
 Vobulazione e biloquenza NEG, Video (8'), Telemuseo Eurodomus, Milan
1972 documenta 5, Kassel
1973 *Antologica,* Pinacoteca Nazionale, Bari
1974 *Photomedia,* Museum am Ostwall, Dortmund
1981 Padiglione d'Arte Contemporanea, Milan
1982 *Lettura interrotta,* Galleria Comunale d'Arte, Bologna

Bibl. *Vincenzo Agnetti, I Dicitori* (New York, 1979), Padiglione d'Arte Moderna, Milan, 1981.

Statement

Immagini e parole fanno parte di un unico pensiero. A volte la pausa, la punteggiatura, è realizzata dalle immagini, a volte invece è la scrittura stessa.
(August 1976)

JOHN BALDESSARI

1931 Born in National City, California. Lives in Santa Monica, California.

Solo exhibitions
1990 Museum of Contemporary Art, Los Angeles
1991 Walker Art Center, Minneapolis
 Whitney Museum of American Art, New York
1992 Musée d'Art Contemporain, Montreal
1994 *The Artist's Choice – John Baldessari, e.g. Grass, Water, Heather, Mouth etc. (For John Graham),* Museum of Modern Art, New York
 Sonnabend Gallery, New York
1995 Margo Leavin Gallery, Los Angeles
 A Retrospective, Cornerhouse, Manchester;

Serpentine Gallery, London; Württembergischer Kunstverein, Stuttgart; Moderna Galerija Ljubljana, Tomšiceva; Museet for Samtidskunst, Oslo; Fundacão Calouste Gulbenkian, Lisbon

Bibl. *John Baldessari,* Württembergischer Kunstverein, Stuttgart, 1995.

Statement

Photos should suggest a word(s) and vice versa. They should be equal and interchangeable.
If words and photos are used in the same work, they should not replicate each other but should do different tasks, neither being more important than the other.

ROBERT BARRY

1936 Born in New York. Lives in Teaneck, New Jersey.

Solo exhibitions
1990 Rena Bransten Gallery, San Francisco
 Haags Gemeentemuseum, The Hague
 Holly Solomon Gallery, New York
 Galerie Meert-Rihoux, Brussels
 Salama-Caro Gallery, London
 Galerie Yvon Lambert, Paris
1991 Galería 57, Madrid
 Galerie Pierre Huber, Geneva
 Galerie Foksal, Warsaw
 Galerie Wassermann, Cologne
 Galleria Ugo Ferranti, Rome
 Le Consortium, Dijon
 Holly Solomon Gallery, New York
1992 Galleria Ugo Ferranti, Rome
 Galerie Clemens Gasser, Bozen/Bolzano
 Wallpiece and New Works, Galerie Bugdahn und Kaimer, Düsseldorf
 Art and Project/Van Krimpen, Rotterdam
1993 Galerie Steinek, Vienna
 Wassermann Galerie, Munich
1994 *Robert Barry, Haim Steinbach,* Galerie Yvon Lambert, Paris
 Galerie Yvon Lambert, Paris
 Holly Solomon Gallery, New York
 Art and Public, Geneva
1995 Galerie Steinek, Vienna
 Robert Barry, Heinz Gappmayr, Kunstraum, Vienna
 Galerie Meert-Rihoux, Brussels

Galerie Clemens Gasser, Cologne
Fellow Workers. Recent "Portraits" from Art World,
Galerie Bugdahn and Kaimer, Düsseldorf

Bibl. *Arts into ideas. Essay on conceptual art*, Cambridge
University Press, Cambridge, 1996.

Statement

There is just something very beautiful about projected images …
photos and words. They are elusive, transitory shadows and
lights referring to something, but transparent, not quite anything
in themselves. At first they seem solid, complete. But they are
illusions we can see but cannot quite grasp. Always changing. Just
on the edge of visibility. There is no narrative, no opinions. Just
isolated words without the text to support them. Dependent
on the context, on their history, their look, form and color. They
are like spoken words. Meaning comes from their relation to
the viewer.
In my more recent photo-words drawings I try to capture some
of this feeling.

JOSEPH BEUYS

1921 Born in Krefeld. Died in Düsseldorf in 1986.

Exhibitions
1953 *Zeichnungen, Holzschnitte, Plastische Arbeiten*,
 Haus van der Grinten, Kranenburg
1963 *FESTUM FLUXORUM FLUXUS*, Düsseldorfer
 Kunstakademie
1964 documenta 3, Kassel
1968 *Raumplastik*, documenta 4, Kassel
1970 *The Pack / Arena*, Edinburgh College of Art,
 Edinburgh
1971 *We are the Revolution*, Modern Art Agency, Naples
1972 *Arena – Dove sarei arrivato se fossi stato intelligente!*
 Modern Art Agency, Naples
 documenta 5, Kassel
 Galleria L'Attico, Rome
1973 Studio Marconi, Milan
 Contemporanea, Rome
1976 *Tramstop, Straßenbahnhaltestelle I*,
 Biennale di Venezia
1977 documenta 6, Kassel
1979 Bienal Internacional de São Paulo
 Retrospective, Solomon Guggenheim Museum,
 New York
1980 *Das Kapital Raum 1970–77*, Biennale di Venezia
1981 *Terremoto in Palazzo*, Fondazione Lucio Amelio,
 Naples
1982 *7000 Eichen*, documenta 7, Kassel
1985 *Palazzo Reale*, Museo di Capodimonte, Naples
1988 *The secret block for a secret person in Ireland*,
 Martin-Gropius-Bau, Berlin, 1988

Bibl. *The secret block for a secret person in Ireland*,
Martin-Gropius-Bau, Berlin, 1988.

Statement

Das eine ist das Bild und das andere ist der Begriff. Der Begriff
ist das eine, da sind die Tafeln, da sind ja die ganzen Begriffe,
etwa Ressourcen, Ökologie, Geldkreislauf, Wirtschaft, Rechts-
situation, Demokratie, Selbstbestimmung, das sind die begriff-
lichen Strukturen, wenn auch in einem Versuch, das Ganze in
einen Zusammenhang, das heißt, in einen wirklichen organischen
Kreislauf zu bringen, die sind ja da. Während das andere ist
die Imagination, das Bild. Auch die Aktion vollzieht sich ja in
Gesten oder in Tönen oder in Formen. Also die Imagination, das
Bild einer Sache ist nicht gleichzusetzen mit seinem Begriff.
Das betrifft natürlich auch die Frage der Interpretation von
Kunst. Denn an und für sich ist Kunst nicht dafür da, daß sie
interpretiert wird. Sie kann interpretiert werden, wenn Kunst-
historiker, wie Sie das jetzt müssen, ikonographische Begrün-
dungen oder Systeme mittels wissenschaftlicher Begriffe oder
überhaupt mit Begriffen beschreiben wollen. Aber das Wesen der
Kunst ist ja nicht das Verstehen mittels der Begriffe, wenn das so
wäre, brauchte es ja keine Kunst zu geben. Denn es läßt sich
alles in Begriffen äußern. Dann bräuchte ich mich ja nur hinzu-
stellen und zu sagen, ich will das und das ausdrücken, diesen und
jenen Sinnzusammenhang, und das kann ich mit der Schreibma-
schine tippen, und dann können die Leute das Buch lesen, und
dann wissen sie Bescheid. Die Aufgabe der Kunst ist ja, die Bild-
haftigkeit des Menschen zu vitalisieren: Erst einmal zu erhalten.
(from: Mario Kramer, Joseph Beuys, *Das Kapital Raum
1970–1977*, Edition Staeck, Heidelberg, 1991.)

HEINER BLUM

1959 Born in Stuttgart. Lives in Frankfurt am Main.

Solo exhibitions
1990 *Kompositionen in Silber und Schwarz*,
 Galerie Artelier, Graz
 Galería Ciento, Barcelona
1991 Sala Parpallo, Valencia
 4 Uhren, Galerie Grässlin-Ehrhardt, Frankfurt am Main

1993 *Lager,* Galerie Tanit, Munich
Museum für Moderne Kunst, Frankfurt am Main
*Warum blasen wir in unsere Suppe, um diese
zu kühlen und in unsere Hände, um diese zu wärmen?,*
Kunsthalle Mannheim
1994 *Läuferbilder,* Galerie Artelier, Frankfurt am Main
1995 *4'33",* Galerie Bärbel Grässlin, Frankfurt am Main
Kunsthalle Baden-Baden

Bibl. *Heiner Blum,* Museum für Moderne Kunst,
Frankfurt am Main, 1993.

Statement

P. W.: Die Strategie mit Text und Fotografie als zwei unterschied-
lichen Informationssystemen zu arbeiten, hat innerhalb der
Konzeptkunst eine bis in die Sechzigerjahre zurückgehende
Tradition. Inwiefern hast du innerhalb dieser Tradition Anknüp-
fungspunkte für deine Arbeit gefunden und inwiefern ist diese
Tradition überhaupt für dich relevant?
H. B.: Ich habe von 1977 bis 1983 in Kassel Fotografie studiert
und mich bis 1981 ausschließlich mit diesem Medium beschäftigt.
Nebenher interessierte ich mich stark für Literatur. 1981 begann
ich mit einer Serie sogenannter "Reprobilder", bei der ich vor
allem aus enzyklopädischen Werken Ausschnitte fotografierte,
die ich dann auf Fotopapier vergrößerte und in Serien zusam-
menstellte. Ein Hauptanknüpfungspunkt dies zu tun, war
Gustave Flauberts Buch *Bouvard und Pécuchet,* das mich auch
noch heute stark beeindruckt.
P. W.: Welche Rolle spielt die Bildgröße bei den Arbeiten, die in
dieser Ausstellung zu sehen sind?
H. B.: Die Bildgröße war für mich bei der Serie "Portraits" ein
außerordentlich wichtiger Faktor. Ich wollte für den Betrachter
ein körperlich wirkendes Gegenüber schaffen. Die Höhe der
Bilder ist so gewählt, daß sie meiner Körpergröße mit erhobenen
Armen entspricht.
P. W.: Gibt es so etwas wie einen aufklärerischen Kern der Arbei-
ten im Sinne einer kritischen Reflexion der Medien, oder spielt
der narrative pointiert-unterhaltende Charakter eine wesentli-
chere Rolle?
H. B.: Meine Arbeiten entstehen ausschließlich aus einem exi-
stentiell-philosophischen Interesse. Die Medien sind für mich
genauso Teil der Wirklichkeit wie alles andere. Inhaltlich be-
schäftige ich mich am liebsten mit den Themen, die alle Menschen
gleichsam betreffen; in meiner Arbeit versuche ich hierfür eine
immer möglichst dichte Form zu finden.
(from a conversation between Heiner Blum and Peter Weiermair,
July 1996)

VICTOR BURGIN

1941 Born in Sheffield, Great Britain.
Lives in San Francisco.

Solo exhibitions
1990 *Family Romance,* John Weber Gallery, New York;
Karl Bornstein Gallery, Los Angeles
1991 Musée d'Art Moderne Villeneuve d'Ascq
Musée de la Ville, Blois
1992 *Fiction Film,* John Weber Gallery, New York
1994 *The End,* John Weber Gallery, New York
Les Quatre Saisons et autres travaux sur la ville,
Galerie Liliane & Michel Durand-Dessert, Paris
1995 Galerie Liliane & Michel Durand-Dessert, Paris
1996 John Weber Gallery, New York
Lisson Gallery, London

Bibl. *Between,* Institute of Contemporary Arts, London, 1986.

Statement

This mixture of "reality", memory, and fantasy – what Freud
called "psychical reality" – is made up not only of images, but
of words too (with narrative playing an important part); so I
also include textual elements in my work. The words in the first
triptych narrate moments from a short story by the eighteenth-
century German writer, Hoffmann – "The Sand Man" (Freud
discusses this story in his essay on "The Uncanny"). The texts in
the second triptych narrate moments from a case history by Freud
and Breuer – "Fräulein Anna O."

WILLIE DOHERTY

1959 Born in Derry, Northern Ireland. Lives in Dublin.

Solo exhibitions
1990 *Unknown Depths,* Ffotogallery, Cardiff
Imagined Truths, Oliver Dowling Gallery, Nottingham
Unknown Depths, Third Eye Center, Glasgow
Same Difference, Matt's Gallery, London
Unknown Depths, Orchard Gallery, Derry
1991 Galerie Giovanna Minelli, Paris
Tom Cugliani Gallery, New York
Unknown Depths, ICA, London; John Hansard
Gallery, Southampton; Angel Row Gallery, Nottingham
Kunst Europa, Six Irishmen, Kunstverein Schwetzingen
1992 Tom Cugliani Gallery, New York
Oliver Dowling Gallery, Dublin

Peter Kilchmann Galerie, Zurich
1993 Galerie Jennifer Flay, Paris
They're All the Same, Center for Contemporary Art,
Ujazdowski Castle, Warsaw
30 January 1972, Douglas Hyde Gallery, Dublin
The Only Good One is a Dead One, Matt's Gallery,
London
1994 *The Only Good One is a Dead One,* Arnolfini, Bristol
1995 Peter Kilchmann Galerie, Zurich
Galerie Jennifer Flay, Paris
Kerlin Gallery, Dublin
1996 Galleria Emi Fontana, Milan
Musée d'Art Moderne de la Ville de Paris
Alexander and Bonin, New York
Edmonton Art Gallery, Edmonton, Canada (and tour)

Bibl. *Willie Doherty,* Edmonton Art Gallery, Edmonton, Canada, 1996.

Statement

My work can be read against the backdrop of Britain's continuing colonial involvement in Ireland. In this respect, it is a contribution to the process of negotiation in a situation which is becoming increasingly characterized by misinformation and censorship.
My images and text seek to problematize the representation of this contested terrain and to destabilize any narrative or literal reading.
(from: Willie Doherty, *Prospect 93,* Frankfurter Kunstverein/ Schirn Kunsthalle, Frankfurt am Main, 1993.)

BERNARD FAUCON

1950 Born in Apt in Provence. Lives in Paris.

Solo exhibitions
1990 Duta Fine Arts Foundation, Jakarta
Institut Français d'Ecosse, Edinburgh
Nikon Live Galerie, Zurich
Institut Français, Freiburg
Galerie Agathe Gaillard, Paris
1991 Galerie Yvon Lambert, Paris
Parco II / Parco III, Tokyo
Picture Photo Space, Osaka
Rebecca Hossack, London
Arcade, Carcassonne
1992 Galeria Modulo, Lisbon
Galeria Modulo, Porto
Centre Culturel Français, Casablanca

Centre Culturel Français, Marrakesh
Centre Culturel d'Albi
1993 Picture Photo Space, Osaka
Galerie Yvon Lambert, Paris
Il Tempo, Tokyo
Château d'Eau, Toulouse
Institut Français, Turin
Institut Français, Budapest
1994 Rebecca Hossack Gallery, London
Galerie Delacroix, Tangier
1995 Picture Photo Space, Osaka
Nun Gallery, Seoul
Galerie Yvon Lambert, Paris
1996 The Photographers' Gallery, London

Bibl. *Bernard Faucon, 12 Menus – Paysages,* Sets de Table, Maison Européenne de la Photographie, 1996.

Statement

Tout a démarré il y a 18 ans. L'évidence enivrante de donner corps à cette folie: pour moi tout sera plus beau, tout sera différent!
J'ai plongé dans l'image photo comme dans un abîme d'alchimiste, y précipitant mon vertige: l'éphémère et le définitif, l'actualité brûlante et la nostalgie, les mannequins, l'enfance, la lumière du Luberon, les pouvoirs magiques de la photo …
Une fusion explosive, un réservoir illimité pour rebondir sans fin de métaphores en métaphores.
Pourtant, à peine commencé, la tentation d'arrêter m'a fasciné. Après "Le Temps des Mannequins", après "Les Chambres d'amour", après "Les Idoles", j'aurais pu clore ce monde parfait si, derrière le jeu voluptueux des métamorphoses, une autre idée ne me travaillait en secret. Celle de mettre en pièce l'échafaudage du mythe, de savourer ce qui reste quand tout a été consommé. "La fin de l'image" ferme la boucle, rejoint le plaisir de montrer et le désir de comprendre, ramène les mots dans la chair d'où ils ont jailli. Petites vérités écrites à même la peau, au degré zéro, lisses, pâles, narguant l'impossible, jouant la sérénité, disant en riant: ce n'était que ça, mais tout de même! Rien n'est perdu, tout l'était déjà!

HAMISH FULTON

1946 Born in London. Lives in Canterbury.

Solo exhibitions
1990 *Selected Walks 1969–1989,* Albright Knox Gallery, Buffalo, New York; National Gallery of Canada,

Ottawa; La Fundación Cultura Televisa A.C. & Centro
Cultural Arte Contemporaneo, Mexico City
Musée de la Peinture et de la Sculpture, Grenoble
John Weber Gallery, New York
Galerie De Laage-Salomon, Paris
1991 *Sleep,* Galerie Tanit, Cologne
Galerie Marika Malacorda, Geneva
Cairn Gallery, Nailsworth, England
Seven Seven Day Walks, Cairngorms Scotland,
Serpentine Gallery, London
Kanransha Gallery, Tokyo
Haags Gemeentemuseum, The Hague
1992 *Winter Solstice Full Moon,* John Weber Gallery,
New York
Kunsthalle Baden-Baden
Abbaye de Saint Savin, France
Galleri Riis, Oslo
IVAM – Centro Julio Gonzalez, Valencia
1993 Annely Juda Fine Art, London
Galleria Massimo Minini, Brescia
Galerie De Laage-Salomon, Paris
1994 John Weber Gallery, New York
Galerie Lydie Rekow, Crest, France
Galeria Luis Serpa, Lisbon
1995 *Horizon Walking,* Centre d'Art Contemporain, Geneva
Galerie Tschudi, Glarus, Switzerland
Städtische Galerie im Lenbachhaus, Munich
Stars Paces, Galerie Tanit, Munich

Bibl. *Hamish Fulton,* Städtische Galerie im Lenbachhaus,
Munich, 1995.

Statement

BUILD
an experience.

The walk *is.*
The artwork is *about …*

Walking is the constant.
The art medium is the variable.

THOUGHTS SILENCED BY BIRDSONG

JOCHEN GERZ

1940 Born in Berlin. Lives in Paris sinces 1966.

Solo exhibitions
1990 Galerie Kicken/Pauseback, Cologne
Galeria Modulo, Lisbon
Galeria Maria Potocka, Kraków
FRAC Champagne-Ardennes, Reims
Museum Schloß Morsbroich, Leverkusen
1991 Galeria Modulo, Porto
Gallery Hirschl & Adler Modern, New York
Kunstverein Ruhr, Essen
Galerie Dreher, Berlin
Galerie Vier, Berlin
Galerie Crousel Robelin Bama, Paris
Galerie Cora Hölzl, Düsseldorf
Galerie Löhrl, Mönchengladbach
1992 Galerie AK, Frankfurt am Main
Galerie Sandmann + Haak, Hanover
Nelson Gallery and Fine Arts Collection, Davis
Pascal de Sarthe Gallery, Los Angeles
Gallery Yill Crowley, Sydney
Neues Museum Weserburg, Bremen
1993 Badischer Kunstverein, Karlsruhe; Corner House,
Manchester; Saarlandmuseum, Saarbrücken; Staatliches
Lindenau Museum, Altenburg; Altes Rathaus, Potsdam
Galerie Sam Lallouz, Montreal
Saidye Bronfman Centre, Montreal
Galerie von Witzleben, Karlsruhe
City Art Gallery, Manchester
Musée Bossuet, Meaux
Galerie Sima, Nürnberg
1994 Musée d'Art Moderne et Contemporain, Strasbourg
Galerie Gandy, Prague
Galerie Löhrl, Mönchengladbach
Vancouver Art Gallery, Vancouver
1995 Newport Harbor Art Museum, Newport Beach,
Los Angeles
Tel Aviv University Art Gallery, Tel Aviv
Galerie Guy Ledune, Brussels
Galerie Chantal Crousel, Paris
Neuberger Art Museum, Purchase, New York
Galerie Bernd Lutze, Friedrichshafen
1996 Galerie Cora Hölzl, Düsseldorf
Gallery CRG, New York
ADDC, Périgueux

Bibl. *Jochen Gerz,* Musée d'Art Moderne et Contemporain,
Strasbourg, 1994.

Der Bestandteil der Arbeit aus Text ist kein Hinzukömmling, der das bereits bestehende Bildelement vehement verändert oder auf dessen eigenem Terrain beeinflußt, dekoriert oder interpretiert. Der Text stammt von mir. Er kommt als Skizze meist in dem Moment zustande, in dem auch die Fotos "nötig" werden, wenn nicht bereits zustande kommen. Der Text, obwohl meist ca. nur 10 Zeilen lang, durchläuft viele Versionen, ehe er auf eine bestimmte Weise ambivalent und lakonisch ist. Wenn ich ihn als perfekt ansehe, heißt das, daß ich nichts mehr mit ihm anfangen kann. Wenn ich ihn in meinem Kopf nicht mehr abbilden kann, und das, obwohl ich ihn lese, ist er in Ordnung.
Es sind Fotos, die zum größten Teil von mir stammen, oder die ich alle hätte selbst machen können. Fotos, die den Eindruck machen, als könnten sie von vielen Leuten gemacht sein. Allerweltsfotos, wenn es das als Allerweltsfotos gäbe (und nicht als sophistisches Kunstwerk). Weekend-Fotos, wenn das Wörtchen "wenn" nicht wäre.
(from: Jochen Gerz, *Texte*, Karl Gerber Verlag, Bielefeld, 1985.)

GILBERT & GEORGE

Gilbert
1943 Born in the Dolomites, Italy. Lives in London.

George
1942 Born in Devon, England. Lives in London.

Gilbert & George met at the St. Martin's School of Art, London in 1967.

Solo exhibitions
1990 *The Cosmological Pictures,* Exhibitions in
 10 European Museums (till 1993)
1993 *Gilbert & George. China Exhibition,* National Art
 Gallery, Peking; The Art Museum, Shanghai
1994 *Shitty, Naked, Human, World,* Kunstmuseum
 Wolfsburg
 The Naked Shit Pictures, South London Gallery,
 London
1995 *The Naked Shit Pictures,* Stedelijk Museum,
 Amsterdam
1996 *Gilbert & George, Retrospective,* Galleria d'Arte
 Moderna, Bologna

Bibl. *Gilbert & George, Retrospective,* Galleria d'Arte
Moderna, Bologna, 1996.

What Our Art Means
Art for all
We want Our Art to speak across the barriers of knowledge directly to People about their Life and not about their knowledge of art. The 20th century has been cursed with an art that cannot be understood. The decadent artists stand for themselves and their chosen few, laughing at and dismissing the normal-outsider. We say that puzzling, obscure and form-obsessed art is decadent and a cruel denial of the Life of People.

Progress through friendship
Our Art is the friendship formed between the viewer and our pictures. Each picture speaks of a "Particular View" which the viewer may consider in the light of his own life. The true function of Art is to bring about new understanding, progress and advancement. Every single person on Earth agrees that there is room for improvement.

Language for meaning
We invented and we are constantly developing our own visual language. We want the most accessible modern form with which to create the most modern speaking visual pictures of our time. The art-material must be subservient to the meaning and purpose of the picture. Our reason for making pictures is to change people and not to congratulate them on being how they are.
(from: *Gilbert & George* [Galleria d'Arte Moderna, Bologna], Charta, Milan, 1996.)

JENNY HOLZER

1950 Born in Gallipolis, Ohio. Lives in New York.

Solo exhibitions
1990 Biennale di Venezia
1991 *The Venice Installation,* Walker Art Gallery,
 Minneapolis
1992 Ydessa Hendeles Art Foundation, Toronto
1993 Kunststation St. Peter, Cologne
 42nd Street Art Project, New York
1994 Art Tower Mito, Mito, Japan
 Bergen Museum of Art, Bergen
 Monika Sprüth Galerie, Cologne
 Black Garden, Nordhorn
1995 *Jenny Holzer: Laments,* Williams College Museum
 of Art, Williamstown, Massachusetts
 Lustmord, Monika Sprüth Galerie, Munich

Bibl. *The Venice Installation*, Walker Art Gallery, Minneapolis, 1991.

Statement

(…) Das Schreiben. Ich konzentrierte mich auf die Sprache, und das war für mich eine große Erleichterung. Einfach über die Dinge reden, die mich beschäftigen. Diese Typen, die an der Straßenecke eine Seifenkiste aufstellen, draufsteigen und gewaltige Reden über Gott und die Welt schwingen – die waren genauso mein Vorbild wie die Konzeptkunst. Als ich anfing, meine ersten Texte auf Postern, Parkuhren, T-Shirts oder Telephonkabinen anzubringen, fühlte ich mich noch nicht als Künstlerin. Ich sah das mehr als Agitprop.
(…) Dies ["Lustmord"] ist mein erster abgeschlossener Zyklus seit drei Jahren, also seit Venedig. Ursprünglich schwebte mir ein Kriegszyklus vor. Er war auch schon teilweise fertig. Aber dann kamen die furchtbaren Nachrichten aus dem Krieg in Jugoslawien: Berichte über Gewalt an Frauen, die mich tief erschütterten. Vergewaltigungen, Verstümmelungen, Mord, Blutvergießen. Greueltaten von entsetzlicher, unvorstellbarer Brutalität. Männer waren die Täter, Frauen die Opfer. So hat sich das Thema zugespitzt.
(…) Es sind insgesamt drei Perspektiven: die des Täters, die des Opfers, und dann die desjenigen, der zurückbleibt. Das kann ein Angehöriger sein, der in seiner Trauer um Worte ringt. Das kann auch nur die Person sein, die die Leiche beseitigen muß. Tod ist keine saubere Angelegenheit, noch dazu, wenn er gewaltsam erfolgt. Am Schluß bleibt immer jemand, der die Dreckarbeit machen muß. Die Texte sind so ausgewählt, daß wir oft gar nicht genau wissen, wer der Beteiligten da zu Wort kommt.
(from: Jenny Holzer, "Der Tod ist keine hygienische Angelegenheit", *Süddeutsche Zeitung Magazin*, No. 46, 1993.)

DOUGLAS HUEBLER

1924 Born in Ann Arbor, Michigan.
Lives in Truro, Massachusetts.

Solo exhibitions
1990 Leo Castelli Gallery, New York
Richard Kuhlenschmidt Gallery, Santa Monica
Galleria Lia Rumma, Naples
1991 Sperone Westwater Gallery, New York
Galleria Gian Enzo Sperone, Rome
Galerie Johnen & Schöttle, Cologne
1993 *Retrospective*, FRAC Limousin, Limoges
1995 *Douglas Huebler, Origine et Destination*,
Palais des Beaux-Arts, Brussels

Bibl. *Die Sammlung Marzona*, Museum für Moderne Kunst – Stiftung Ludwig, Vienna, 1995.

Statement

Aphorisms (culturally determined terms of social reality) are used in *Variable Piece No. 70, 1971* as its "constant" component while photographs of people (mechanically determined terms of reality) function as its "variable." Each term is a kind of ready-made which, when associated with the other, produces a context for a dialectical process which is, in fact, the **real** subject of the work.
The percipient engages in the dialectic while realizing that there is no necessarily correct way to read a conclusive meaning in the association of the two terms: to the contrary, any number of readings are indicated. For instance, in an aphorism such as, "Represented above is at least one person who is poor, but happy," one might imagine that any one of the people who appear in the photograph may be the subject, or none of them. **In that no specific** "meaning" is intended to be inferred from the association between the people who appear in a given photograph and the aphorism that appears along with it, no kind of "conclusion" can be reached thereby foreclosing the likelihood of such a work being consumed: it exists in the present, a model of how meaning itself may be formulated, while generating in its percipient a fresh sense of his/her freedom of choice.
The form of the work accommodates the use of events, and socio/political phenomena of all kinds normally located in "real life," examples of which include "Dachau," "FBI Wanted Bulletins," "pornographic photograph," etc. (The literal content of such topics is defamiliarized by its use within the dialectical process.)
The *Crocodile Tears*, a series of recently fabricated works, the topic is the art world: artists, collectors, dealers, politics, etc. **Fiction** joins with the constant/variable continuum to "re-sound" from the other terms in such a way as to further animate the dialectical experience of an individual piece.
Nothing said in the foregoing discourse should be taken to imply that the **visual** characteristics of *Variable Piece No. 70* are of secondary importance: after being "washed through" the dialectic they emerge value-free, and are thereby returned to their natural state as undifferentiated phenomena where they exist to be simply **seen.**

PETER HUTCHINSON

1930 Born in England.
 Lives in Provincetown, Massachusetts.

Solo exhibitions
1990 *Photographs & Collages,* Hell's Kitchen Gallery,
 Provincetown
 Small Photos & Collages, Galerie Hadrian Thomas,
 Paris
1991 *An Alliterative Alphabet,* Berta Walker Gallery,
 Provincetown
 Zoe Gallery, Boston
 Recent Work – An Alliterative Alphabet,
 Holly Solomon Gallery, New York
1992 *An Alliterative Alphabet,* The Butler Institute of
 American Art, Youngstown, Ohio
1993 *Recent Works,* Galerie Bugdahn und Kaimer,
 Düsseldorf
 Landscapes, Berta Walker Gallery, Provincetown
1994 *Growth Potential,* Holly Solomon Gallery, New York
 Galerie Blancpain-Stepczynski, Geneva
 The Narrative Art of Peter Hutchinson: A Retrospective,
 Provincetown Art Association and Museum,
 Provincetown
1995 *Portraits,* DNA Gallery, Provincetown
 Retrospective & Recent Landscapes, Holly Solomon
 Gallery, New York
 Landscapes & Constructions, Galerie Bugdahn und
 Kaimer, Düsseldorf
 Landscapes & Concepts, Torch Galerie, Amsterdam

Bibl. *The Narrative Art of Peter Hutchinson: A Retrospective,* Provincetown Art Association and Museum, Provincetown, 1994.

Statement

In the late 1960s I worked with photos of my land art to which I added text. These I called *Documentations,* since the text described the photos and what happened in them. Then in *Paricutin Project,* my volcano piece of Jan. 1970 and *Foraging* of that year, the text began to expand. In 1972 in *Narrative Pieces,* the texts became more personal and told stories or "narratives" and had more oblique and subtle relationship to the photos. At this point the photo and text separately would convey quite a different meaning. Together they activate both sides of the brain, the photo dealing with the left side and the narrative with the right. There is a lot of play in the amount of relationship between the two (photos, writing and also of course left and right sides!). In a recent 1996 piece, for instance, the narrative deals as a diary with the day's events. The only direct relationship to the photo is when I finish the text: "And then I went to the studio to finish this work."

ON KAWARA

(Sept. 13, 1996)

23,274 days

KAREN KNORR

1954 Born in Frankfurt am Main. Lives in London.

Solo exhibitions
1990 *Vues de l'Esprit, Photographies,* Galerie Le Lieu,
 Lorient
1991 *Capital,* Salama-Caro Gallery, London
 Connoisseurs and Capital, Galería 57, Madrid
 Gentlemen, Country Life, Connoisseurs and Capital,
 Galerie Antoine Candau, Paris
 Marks of Distinction, Portfolio Gallery, London
1993 *Inside Out,* Museo d'Arte Contemporanea Luigi Pecci,
 Prato
 Britain Your Britain, The Towner Art Gallery,
 Eastbourne
 The Virtues and the Delights, Canterbury University,
 Keynes University; Interim Art, London
 Karen Knorr, Photografiska Museet, Moderna Museet,
 Stockholm
1994 *The Virtues and the Delights,* Royal Festival Hall;
 Portfolio Gallery, Edinburgh; Nederlands Foto
 Instituut, Rotterdam
1995 *Academies,* Galerie Philippe Rizzo, Paris
 The Virtues and the Delights, Galerie Blancpain-
 Stepczynski, Geneva

Bibl. *Multiple Exposures,* Independent Curators Inc., New York, 1995.

Statement

Walter Benjamin writes of a type of photograph which was becoming prevalent in his time:
"But now let us follow the subsequent development of photography. What do we see? It has become more and more subtle, more and more modern, and the result is that it is now incapable

of photographing a tenement or a rubbish heap without transfiguring it. Not to mention a river dam or an electric cable factory: in front of these, photography can now only say, 'How beautiful'"[1].

The uncritical photographic flaneur is amongst us photographing into our intimate spaces with long focal lenses certain peopled actions are caught unawares and the buildings of urban centres are photographed with the appropriate rhetoric of the objective eye, blown up displayed to show us how the world is beautiful.

Photographs of low income housing, factories, portraits of council flat tenants, city architecture, factories, dysfunctional families, subculture and fashion all clamour for our attention in the media and on the walls of international museums. Museums and galleries no longer elitist milieus have broken football match attendance records. In this new climate what is the function of the photograph? How do we address the increasingly impatient spectator who yearns for the quick fix appeal of the spectacle? Our gallery going public are now all domestic photographers and videographers. How do we slow down the flow of consumption of spectators that seek the cheap fairground attraction aesthetics of contemporary art and its tragic anatomies of mutant children? Art competes with the cinema. Photography's gesture has become larger and larger. It is now projected huge and silent reverting to its older spectacular appeal as diorama. In the rush to be part of one's time artists have amnesia. They forget history and reinvent the wheel except now the wheel is larger and turns at the speed of megabytes.

The point for Benjamin in his seminal essay *The Author as Producer* was that an unchanged production apparatus was being supplied by a particular type of photography. This photography which was the New Objectivity of the 1920's and 30's which did not change the production apparatus nor for that matter the world it photographed. Today the wall has come down but certain things have not changed.

"What we must demand from the photographer is the ability to put a caption beneath his picture as will rescue it from the ravages of modishness and confer upon it a revolutionary use value."[2]

Walter Benjamin believed in the power of technological innovation and the blurring of distinctions between what were once separate spheres of competence. Writers photograph. Photographers write. Then as now it is a matter of disrupting the photograph as an object which transforms human misery into an object of consumption. This position still makes sense today even if we have less hope in technical or revolutionary progress than he had in his day.

Text and language with photographs can help slow down this feeding frenzy for consumption that now describes the modern spectator of the arts. Text and photographs has become one of the strategies of some post modern artists who have attempted to question the politics of consumption and power. A new space between text and image, sound and image, that creates a reflective space inviting the beholder to linger the captions, stories, legends, histories, photographs and texts equal, mutually independent and fully collaborative.

[1] Walter Benjamin, "Understanding Brecht," *The Author as Producer*, New Left Books, London 1973, p. 94-95.

[2] ibid., p. 95.

JOSEPH KOSUTH

1945 Born in Toledo, Ohio. Lives in New York and Gent.

Solo exhibitions
1990 *Das Spiel des Unsagbaren: Ludwig Wittgenstein und die Kunst des 20. Jahrhunderts,* Palais des Beaux-Arts, Brussels
 The Play of the Unmentionable, The Brooklyn Museum, Brooklyn, New York
 Tabula Rasa, Galería Juana de Aizpuru, Madrid
 An Exhibition On About or Using Ludwig Wittgenstein, Margo Leavin Gallery, Los Angeles
1991 Galerie Peter Pakesch, Vienna
 Galleria Lia Rumma, Naples
 Three Installations: 1970, 1979, & 1988, Rubin Spangle Gallery, New York
 Un Aleph, Ex Libris (Para J.L.B.), Ruth Benzacar Galería de Arte, Buenos Aires
1992 *Podobenstvi (Ex Libris Kafka),* Belvedere, Prague
 Kein Ding, kein Ich, keine Form, kein Grundsatz (sind Sicher), Villa Merkel, Esslingen
 A Play: The Harald Tribune, Kafka and a Quote, Hirshhorn Museum, Washington
 Covered – Uncovered, Galerie Achim Kubinski, Cologne
1993 Galería Juana de Aizpuru, Seville
 7 Orte auf der Karte eines Gesprächs, Galerie der Stadt Stuttgart
 (Eine grammatische Bemerkung), Württembergischer Kunstverein, Stuttgart
 Zeno at the Edge of The Known World, Biennale di Venezia
 The Thing-in-itself is found in its Truth through the loss of its immediacy, Leo Castelli Gallery, New York
 Double Reading. Allegory of limits, Margo Leavin Gallery, Los Angeles
1994 *Berliner Chronik,* Kunstwerke Berlin
 Review of works, Exhibition Space, Tokyo

Bibl. *(Eine grammatische Bemerkung),* Württembergischer Kunstverein, Stuttgart, 1993.

Statement

So then I used photostats of dictionary definitions in a whole series of pieces. I used common, functional objects – such as chair – and to the left of the object would be a full-scale photograph of it and to the right of the object would be a photostat of a definition of the object of the dictionary. Everything you saw when you looked at the object had to be the same that you saw in the photograph, so each time the work was exhibited the new installation necessitated a new photograph. I liked that the work itself was something other than simply what you saw. By changing the location, the object, the photograph and still having it remain the same work was *very* interesting. It meant you could have an art work which was that *idea* of an art work, and its formal components weren't important. I felt I had found a way to make art without formal components being confused for an expressionist composition. The expression was in the idea, not in the form – the forms were only a device in the service of the idea.
(from: *Joseph Kosuth: Interviews, 1969–1989*, Ed. Patricia Schwarz, Stuttgart, 1989.)

BARBARA KRUGER

1945 Born in Newark, New York. Lives in New York.

Solo exhibitions
1990 Monika Sprüth Galerie, Cologne
Duke University Museum of Art, Durham
Rhona Hoffman Gallery, Chicago
Kölnischer Kunstverein, Cologne
1991 Mary Boone Gallery, New York
1992 MAGASIN, Centre National d'Art Contemporain, Grenoble
1994 Mary Boone Gallery, New York

Bibl. *Love for Sale: The words and pictures of Barbara Kruger*, Harry N. Abrams, New York, 1990.

Statement

Ich hoffe, in meiner Arbeit treffen Bilder und Worte einander. Sie kann, bis zu einem gewissen Grade, verschiedenen Betrachtern verschiedene Bedeutungen nahelegen.
Die meisten Sätze schreibe ich selbst. Einige sind Bruchstücke kultureller Alltagssprache, die irgendwie gemütlich familiär klingen. Ich versuche, sie umzukrempeln, damit zum Vorschein kommt, was sie eigentlich bedeuten könnten.
Ich benutze vorhandene Bilder und versuche, sie ein bißchen aus der Form zu biegen. Es ist, als ob ich sie recycle und wieder benutzbar mache.

Einige Arbeiten sind geschlechtsspezifisch, während es bei anderen spezieller um Geld, Tod und Macht zu gehen scheint. Aber natürlich sind all diese Themen miteinander verbunden und helfen zu formen, wie es sich anfühlt, ein Leben zu leben.
(from: Barbara Kruger, *Buchstäblich, Bild und Wort in der Kunst heute,* Von der Heydt-Museum, Wuppertal, 1991.)

KETTY LA ROCCA

1938 Born in La Spezia. Died in Florence in 1976.

Solo exhibitions
1970 *Le presenze alfabetiche e lo spazio parlando,* Palazzo dei Musei, Modena
1971 *Novi-lunio,* Palazzo dei Diamanti, Ferrara
Accumulazioni, Galleria Flori, Florence
1972 Galleria Seconda Scala, Rome
1973 Galleria Christian Stein, Turin
1975 *You, you,* Galleria La Tartargua, Rome
1978 *Retrospettiva,* Biennale di Venezia
1989 *Retrospettiva,* Galleria Carini, Florence
1995 *Ketty La Rocca,* Künstlerhaus Stuttgart

Bibl. *Ketty La Rocca, Retrospettiva,* Galleria Carini, Florence, 1989.

Statement

Qual'è, oggi, la situazione della poesia, considerato quanto abbiamo premesso? O meglio, considerato che la parola "poesia", con la quale qualcuno vorrebbe ancora catalogare operazioni non più catalogabili, è ormai poco significativa, se mai lo è stata (vi sono nel linguaggio segni consumati da millenni): qual'è, oggi, la situazione del linguaggio poetico? Stando le cose al punto in cui stanno, tutti avvertono il bisogno che ogni operatore, prima o dopo aver compiuto una operazione, si affretti a dichiarare le proprie intenzioni e fornisca le regole del discorso proposto; e così facciano quelli che possano sospettare di aver compiuto delle operazioni poetiche.
Fermo restando un punto: che qualsiasi valore, finalità, contenuto, forma ecc., egli voglia dare alla propria costruzione poetica, questa sarà in ogni caso prima di tutto linguaggio, dovrà cioè *significare* qualcosa, vale a dire essere capace di realizzare una situazione di comunicazione: in quanto, almeno per chi respinge la mistica dei significati intrinsechi, non si dà significato al di fuori di una situazione intercomunicante.
(from: Ketty La Rocca, "Crisi nell'arte e poetica nostrana", *Letteratura,* No. 82-83, 1966.)

MARIE-JO LAFONTAINE

1950 Born in Antwerp. Lives in Brussels.

Solo exhibitions
1990 Arco Madrid Galerie Walter Storms, Madrid
 Passio, Städtisches Museum Abteiberg,
 Mönchengladbach
 A fleur du mal, Salzburger Kunstverein, Salzburg;
 Städtisches Museum Schloß Hardenberg, Velbert
 Widerstand, Städtische Galerie, Göppingen
 Savoir retenir et fixer ce qui est sublime, Musée
 des Beaux-Arts, Tourcoing
 La vie … une hésitation, Galerie Montaigne, Paris
1991 *L'étoile filante*, Wewerka-Weiss Galerie, Berlin
 Ric Urmel Gallery, Gent
 Immaculta, Bergkerk Kunst, Deventer
 We are all shadows, Galerie Walter Storms, Munich
1992 *Memoria*, Archief, The Hague
 Galerie Montaigne, Paris
 Vereins- und Westbank, Hamburg
 Métronome de Babel, Museum Lübeck
 And after the orgy, Noordijlaandskunstmuseum,
 Aalborg
 History is against forgiveness, Goethe Institut,
 Brussels
 We are all shadows II, Museum of Art Fondation
 Helena Rubinstein, Tel Aviv
1993 *Als das Kind noch Kind war*, Galerie Bugdahn,
 Düsseldorf
 Himmel und Hölle, Galerie Deweer, Ottegem
1994 *Victoria*, Smith College Museum, Massachusetts
 Installation Vidéo nuages et mer, Lisbon 94, Lisbon
 Als das Kind noch Kind war, Galerie Comicos, Lisbon
 Savoir retenir et fixer ce qui est sublime, University Art
 Museum California State, Long Beach, California
 Le cercle de feu, Wanâs Mobile, Malmö
 Jeder Engel ist schrecklich, Gasometer, Oberhausen
 Galerie Bugdahn, Düsseldorf
 Galerie Walter Storms, Cologne
1995 Galerie Thaddaeus Ropac, Paris
 Galerie de Gryse, Tielt
 Art fair solo show, Galerie Ropac, Brussels
 Galerie Rigassi, Berne
 Die Muse, Galerie Thaddaeus Ropac, Salzburg
 Festspielhaus, Salzburg
1996 La nature morte, Galerie Thaddaeus Ropac, Salzburg
 Galerie Bugdahn und Kaimer, Düsseldorf
 Galerie Wanda Reiff, Amsterdam

Bibl. *Die Muse*, Galerie Thaddaeus Ropac, Salzburg, 1995.

Statement

Meine Foto-Text-Arbeiten zielen auf zwei Formen des Gedächt-
nisses: auf das visuelle und auf das verbale. Beide müssen in
der einzelnen Arbeit nicht unmittelbar zueinander in Beziehung
treten. Sie können isoliert voneinander bestehen bleiben. Das
eigene Erinnern ist maßgebend, solange es nonverbal verharrt,
wie in der Fotografie.
In der Fotografie hast du die Geschichte, ähnlich wie im Quattro-
cento, in der Predella ist sie eingefroren in ihrer Verschwiegen-
heit.
Die Wörter sind nur Instrumente, die einem die Möglichkeit
geben, seine Wahrnehmung zu beschreiben, unzulänglich, un-
vollständig.
Die Wörter geben einem die Möglichkeit, die Bilderfahrung zu
dekodieren und sind dabei doch nur eine Ordnungslinie.
Die Wörter können auch Verwirrung stiften, so wie die Pfeife
von Magritte.

LOUISE LAWLER

1947 Born in Bronxville, New York. Lives in New York.

Solo exhibitions
1990 *A Vendre*, Galerie Yvon Lambert, Paris
 *The Enlargement of Attention, No One Between
 the Ages 21 and 35 is Allowed, Connections: Louise
 Lawler*, Museum of Fine Arts, Boston
1991 *For Sale*, Metro Pictures, New York
 Galerie Meert-Rihoux, Brussels
1992 Galerie Isabella Kacprzak, Cologne
1993 Sprengelmuseum, Hanover
1994 Centre d'Art Contemporain, Geneva
 External Stimulation, Galleria Clemens Gasser,
 Bozen/Bolzano
 Studio Guenzani, Milan
 Metro Pictures, New York

Bibl. *Louise Lawler*, Centre d'Art Contemporain, Geneva, 1994.

Statement

A photograph is one kind of information. It can be made more or
less explicit with a text.
You are told "some things" about "something"; never everything.
By being "told" you hopefully are more aware that someone is
"telling"; choices have been made and can continue to be made.

JEAN LE GAC

1936 Born in Tamaris, France. Lives in Paris.

Solo exhibitions
1990 Galerie Daniel Templon, Paris
 Galerie Taidegraafikot, Helsinki, Finland
 Galerie Catherine Issert, St. Paul-de-Vence, France
1991 Galerie Jade, Colmar, France
 Galerie Brigitte March, Stuttgart
 Galerie Sandmann et Haak, Hanover
1992 Badischer Kunstverein, Karlsruhe
 Stadt Galerie, Saarbrücken
 Espace Fortant de France, Sète, France
 Galerie Catherine Issert, St. Paul-de-Vence, France
 Willy D'Huysser Gallery, Brussels
 Galerie Daniel Templon, Paris
 Nijmeegs Volkenkundig Museum, Nijmegen
 Galerie De Gele Rijder, Arnhem
 Centre d'Art Contemporain/Kunsthalle, Fribourg
1993 Musée Léon Dierx, St. Denis-de-la-Réunion, La Réunion
 Galerie Knapp, Lausanne
 Domaine du Dourven, FRAC Bretagne
1994 Galerie Catherine Issert, St. Paul-de-Vence, France
 Sala Parpallo, Palau del Scala, Valencia
 Galerie Pascual Lucas, Valencia
 L'épisode d'Antony, Maison des Arts, Antony
1995 Galerie Daniel Templon, Paris
 La boîte de couleur, FRAC Picardie, Amiens
 Galerie Alesandro Sales, Barcelona
 Galerie Knapp, Lausanne
 La rumeur dans la montagne, Galerie Brigitte March, Stuttgart

Bibl. *Jean Le Gac*, Badischer Kunstverein, Karlsruhe, 1992.

Statement

En tant qu'artiste je me suis vite senti promis à la disparition et à la mort lente. De toutes mes ambitions de jeunesse il ne me resta bientôt plus qu'un mot sans grande consistance mais qui me troublait encore, "le peintre".
De ce désir de l'entendre résonner dans ma langue et de le chuchoter une dernière fois à mon oreille, sont nées mes images (pas seulement photographiques) avec texte.
Cette forme nouvelle du doute n'est ni du côté du photographe, ni de l'écrivain. Elle est au mur le tableau absent, l'œuvre disparue et l'enquête sur cette disparition.
Face aux produits culturels j'aimerais assez que ce calme substitut ait la moralité d'une fable.

KEN LUM

1956 Born in Vancouver, Canada. Lives in Vancouver.

Solo exhibitions
1990 Witte de With Center for Contemporary Art, Rotterdam
 Galerie Meert-Rihoux, Brussels
 Galleri Nordanstad-Skarstedt, Stockholm
 Andrea Rosen Gallery, New York
 Vancouver Art Gallery, Vancouver
 Winnipeg Art Gallery, Winnipeg
 Artspeak Gallery, Vancouver
1991 Galerie Rüdiger Schöttle, Paris
 Galerie Daniel Buchholz, Cologne
 Fine Arts Gallery, University of British Columbia, Vancouver
 Galerie Rüdiger Schöttle, Munich
 Kunstmuseum Lucerne
1992 Galleria Massimo De Carlo, Milan
 Andrea Rosen Gallery, New York
1993 Städtische Galerie im Lenbachhaus, Munich
 Neue Galerie am Landesmuseum Joanneum, Graz
 Stadtgalerie, Saarbrücken
 Badischer Kunstverein, Karlsruhe
 Galerie Johnen & Schöttle, Cologne
 Galerie Daniel Buchholz, Cologne
1994 Oakville Galleries, Oakville, Ontario
 Catriona Jeffries Gallery, Vancouver
 Andrea Rosen Gallery, New York
1995 Salle d'Expositions, École Nationale des Beaux-Arts, Nancy
 L'Aquarium – Galerie de l'Ecole Nationale des Beaux-Arts, Valenciennes
 DRAC, Lorraine
 Galerie Nelson, Paris
 Walter/McBean Gallery, London
 Camden Arts Centre, London
 Stills Gallery, Edinburgh
 Galerie Drantmann, Brussels
1996 Stills Gallery, Edinburgh

Bibl. *Fact or Fiction? Four Canadian artists*, Museum of Contemporary Art, Sydney, 1996.

Statement

Well, first of all, they [text and image] are two different systems. Even when you overlay them on the top of one another, they are always two different systems, and I think that even when you see

an ad in which you have a line of text and right below it a picture of something, there is always a kind of difference in terms of your regard. You look at the image, you look at the text; you look at the text, you look at the image. It's never like you look at it all at once. Or very rarely; I don't know if it ever exists, whereby you look at them as a unit, together. But the other thing, one of modernism's great characteristics, was its attention to the reflexive, that something calls attention to itself. By separating them formally the text calls attention to the limitation of the picture and the picture calls attention to the limitation of the text, so that you are never locked into the picture, so to speak, completely, because there's always some text which takes you outside the picture, but interestingly enough, in my work, I wanted the text to lead back into the picture and vice versa, and so it was a kind of double reflexiveness that I was after.
(from: "Ken Lum," *Transcript,* vol. 2, issue 1, 1996.)

URS LÜTHI

1947 Born in Lucerne, Switzerland. Lives in Munich.

Solo exhibitions
1990 Helmhaus, Zurich
 Kasseler Kunstverein, Kassel
1991 Galerie Tanit, Munich
 Kunsthaus Glarus, Glarus, Switzerland
 Cabinet des Estampes, Geneva
1992 Galerie Tanit, Cologne
 Neue Galerie Dachau
1993 Galerie Stadtpark, Krems
 Bonner Kunstverein, Bonn
 Galerie Blancpain-Stepczynski, Geneva
1994 Galerie im Stadthaus, Klagenfurt
 Chapter, Cardiff, Wales
 Galleria Civica, Modena
 Aargauer Kunsthaus, Aarau
 Freiburger Kunstverein, Freiburg i. Br.
 Galerie Maximilian Krips, Cologne
1995 Galerie Sollertis, Toulouse
 Museum Wiesbaden
 Studio Morra, Naples
1996 Galerie Tanit, Munich
 Galerie Blancpain-Stepczynski, Geneva
 PPOW Gallery, New York

Bibl. *Urs Lüthi,* Museum Wiesbaden, 1995.

Statement

Das ist wirklich wie bei dem Alphabet, wo die Buchstaben entwickelt sind, mindestens für einen Künstler sind die ja Allgemeingut geworden. Das Ziel ist jetzt mit dem, was wirklich als Grundstock daliegt, eben der ganzen Kulturgeschichte der letzten paar hundert oder tausend Jahre, anzufangen, unser Weltbild zu erstellen, also eine Utopie im Grunde genommen. Die Voraussetzung ist allerdings eine starke Dosis an Ehrlichkeit und auch an Verantwortlichkeit. Es geht darum, daß wir versuchen, eigene Zusammenhänge aufzuzeichnen, die nicht mehr schon in ganz bestimmten Bahnen vorgelenkt sind, eben Stile, die gerade angesagt sind, wie das die letzten hundert Jahre fast immer der Fall war.
(from a conversation with Christoph Blase, in: *Wo der Traum in Liebe endet,* Kunstverein Munich, 1987.)

DUANE MICHALS

1932 Born in McKeesport, PA. Lives in New York.

Solo exhibitions
1990 Centro de Arte Moderna da Fundacão Calouste Gulbenkian, Lisbon
 A Gallery for Fine Photography, New Orleans
 Cumberland Gallery, Nashville
 Andrew Smith Gallery, Santa Fe
 Fahey/Klein Gallery, Los Angeles
 Fay Gold Gallery, Atlanta
 Vrais Rêves, Lyon
 Institut de la Communication, Université Lumière, Lyon
 The Duane Michals Show, Museum of Photographic Arts, San Diego (and tour)
 Duane Michals: Portraits, Butler Institute of American Art, Youngstown (and tour)
1991 Galerie Bodo Niemann, Berlin
 Aspen Art Museum, Aspen, Colorado
 Poetry and Tales, Sidney Janis Gallery, New York
 Robert Koch Gallery, San Francisco
 Kunstraum Fleetinsel, Elke Dröscher, Hamburg
 Busche Galerie, Cologne
1992 Lynn Goode Gallery, Houston
 Kunstraum Fleetinsel, Elke Dröscher, Hamburg
 Espace Photographique de Paris
 Portfolio Gallery, Edinburgh
 Paris Stories and Other Follies, Sidney Janis Gallery, New York
 Montgomery Glasoe Fine Art, Minneapolis

Beam Gallery, Tokyo
1993 Ehlers Caudill Gallery, Chicago
Fahey/Klein Gallery, Los Angeles
The Irish Gallery of Photography, Dublin
The Temple Bar Gallery, Dublin
Galeria USVU, Bratislava
Sala Parpallo, Valencia
University of North Florida, Jacksonville
1994 Lynn Goode Gallery, Houston
Duane Michals, Louisiana Museum, Humlebaek
Questions Without Answers, Sidney Janis Gallery,
New York
1995 *Duane Michals*, Right Gallery, Kamakura
Questions Without Answers, Hamiltons, England
(and tour)
Duane Michals, Photographic Center, Atlanta;
Braunschweig Photomuseum

Bibl. *Duane Michals*, Louisiana Museum, Humleback, 1994.

Statement

A Photograph Is Not Worth A Thousand Words
Traditional photographers are unaware that they live in a world
of make believe and assume the hard reality of appearances to be
the only possible subjects for photographic documentation.
Common sense dictates that to be real is to be fact. This narrow
definition of reality reduces him to the role of the perpetual spec-
tator who can only record the transient cavalcade of random
events that distracts the observer from questioning the very
nature of this display and of himself. The view seen through
the rectangular frame of the camera's lens is, however, just a small
slice of the complete circle of experience. In the west, one is a
witness to the event; in the east, one is event. The famous *decisive
moment* is for the photographer only a description of an instant
that is perfectly observed, when that moment itself is actually a
profound Buddhist concept.
If one experiences a subtle shift in consciousness, then what mat-
ters is not what something looks like but, more importantly, what
something feels like. What needs to be expressed is an intimate
revelation into the nature of the very thing itself, not just a visual
reproduction of it. The need is to see through appearances, like a
theatrical scrim, into the actuality behind it. When I see a photo-
graph of a woman crying it is the nature of her grief that touches
me, not the appearance of tears, which is merely a clue to her
unhappiness. If the potential of this moment falls as a poetic
experience, the failure lies in the very mechanical limitation of the
camera to transcend its function to reproduce with clear fidelity
what it views at the moment. It performs as the perfect recorder
of what is out there, but nothing else.

How can one deal with what is also out there unseen? What
about the reality of the imagination, the urgency of desire, the
mysteries of the metaphysical and the whims of our emotions?
These can only be suggested or alluded to on film. Somehow
there must be more. What to do? The solution to this problem is
to enhance photography with language in a symbiotic relation-
ship. Language has always been a constant companion to the
photograph. A captioned photograph identifies for the viewer the
time, date and name of the subject seem. It labels the picture for
us. Language can complement the picture as a form of suggestion
into what cannot be seen within its two-dimensional space. One
can be more intimate and specific with language. This impulse to
writing is born out of the frustration with the silence of the
photograph, out of the need to somehow make it speak and
share its secrets. This is not an abandonment of the photograph
but an expansion of the possibilities of expression. What must be
abandoned is the *idée fixe* of the purity of the camera as a perfect
vehicle for reproducing reality and beyond the need of collab-
oration. The artist should not be defined by the medium but must
redefine the medium for his own purposes. A photograph is not
worth a thousand words. Everything is, after all, a thought.

MAURIZIO NANNUCCI

1939 Born in Florence. Lives in Florence and Paris.

Solo exhibitions
1990 Galerie Martina Detterer, Frankfurt am Main
Galeria Bruno Musatti, Sao Paulo
Gallery Isam Gleicher, Chicago
1991 Gallery Victoria Miro, Florence
Galleria Massimo Minini, Brescia
Städtische Galerie im Lenbachhaus, Munich
1992 Villa delle Rose, Galleria d'Arte Moderna, Bologna
Villa Arson, Nice
1993 Usine Fromage, FRAC Haute Normandie, Rouen
Galerie Gilbert Brownstone, Paris
Kasseler Kunstverein, Fridericianum, Kassel
1994 Bibliothèque Nationale de France, Paris
Aarhus Kunstmuseum (Turell, Nannucci, Nauman)
1995 Wiener Secession, Vienna
1996 Ecole des Beaux-Arts, Bourges
Galerie Walter Storms, Munich
Dadart Virtual Gallery, Florence (Internet)

Bibl. *Another Notion of Possibility*, Wiener Secession, Vienna,
1995.

Il testo situato al margine della foto riscrive in un altro modo l'idea dell'immagine: una specie di protocollo per/della memoria riguardante il luogo ed il tempo. I sogni linguistici relazionano la poesia dell'immenso, del fluido e dell'indefinito, generando una complessa ambiguità.

Si può leggere ed orientarsi tra questi segni, – oppure no.

Si può considerare questi segni brevi e veloci come una mutazione dell'immagine, – oppure no.

Si può comprendere questi segni come un ordine che struttura il disordine, – oppure no.

In ogni caso la reversibilità tra segno linguistico e segno visivo fa si che non un linguaggio prevalga sull'altro. L'alternanza tra la concretezza delle parole e le sensazioni visive non dette esprime la coscienza del linguaggio ed anche dell'immagine.

SHIRIN NESHAT

1957 Born in Qazvin, Iran. Lives in New York.

Solo exhibitions
1993 *Unveiling,* Franklin Furnace, New York
1994 *Woman of Allah,* University of California, Los Angeles
1995 Annina Nosei Gallery, New York
1996 The Haines Gallery, San Francisco
 Galleria Lucio Amelio, Naples

Statement

The development of my photographic work began as a response to writings by contemporary Iranian women. My images were enhanced by the spirit and emotional qualities I have found in these women's words. I discovered that their system of communication – expression about the state of their personal and public lives were similar to mine: minimal, emotional, complex but concise. My images visualized their words. To some degree I began to treat my photographs as poetry. Similar to a writer, I established my vocabulary: the veil, the body, the text, the firearms, and then I continued to improvise within this framework.

My interest in the application of the text over my photographic images is related to the subject matter, and my interest in suggesting the intellectual strength that I believe exists behind the female identity in Islam. The text therefore functions as a voice, a voice to question the stereotypically negative and victimizing qualities associated with Islamic women.

My selection of text varies according to the theme of the work. I have often applied Forough Farokhzad's poetry to my photographs. Farokhzad, who died in her early thirties, is considered one of the greatest modern poets in the history of Iranian literature. Forough's writing are about her experiences as a woman in Iranian culture. Her poetry is extremely personal yet speaks about emotions that might live behind every woman's heart and mind. She regularly breaks social boundaries in order to claim what she desires: her body, sexual needs, longing and despair, and her poetry penetrates us precisely because of this daring style. Unquestionably, the spirit of her approach has been a driving force in my photography.

Another Iranian writer who has been extremely influential in my work, in particular in the development of the *Women of Allah* series, is Tahereh Saffarzadeh. Tahereh's poetry, contrary to Forough's themes, is religious and expresses little about her personal world. Tahereh, who also enjoyed a Western education, is intensely involved with the Islamic revolution. As a result, her commitment to Islam becomes a major force in her writing. Her poetry is often about women's desires to participate in the revolution. She supports Islamic ideology and the advancement of the community as opposed to the individual. Tahereh's passionate expression of her religious conviction is rationally engaged, yet emotional and extremely feminine: all qualities which support, elevate and define my photography.

LAURA PADGETT

1958 Born in Cambridge, USA.
 Lives in Frankfurt am Main and Weimar.

Solo exhibitions
1991 Galerie Sequenz, Frankfurt am Main
1993 Galerie Sequenz, Frankfurt am Main
1994 *Telltales,* Forum der Frankfurter Sparkasse 1822,
 Frankfurt am Main
1995 *conditions of contingency,* Galerie Hübner, Dresden
1996 *common occurences,* Galerie KunstRaum Klaus
 Hinrichs, Trier

Bibl. *Prospect 96 – Photographie in der Gegenwartskunst,* Frankfurter Kunstverein; Schirn Kunsthalle, Frankfurt am Main, 1996.

Statement

Photography and the written word: two utterly common means of communication constantly found together. Their combination being so familiar, our visual literacy gives us the sense that we already know what we're looking at and reading when confronted with this constellation. Yet what happens when we read something, when we look at a photograph? Do we know what

we're looking at, do we know what we're reading – not only in terms of recognizing what we see, but whether the compound image is claiming something that's true? Seeing is believing, a statement we have been unable to contend for quite some time. Is that right? Most often, when we read something our mind's eye produces images, just as when we look at an image we relate it to concepts. It's not a question of *believing what* we see but *that we understand what* we see. Situations shift.

Within these shifting situations, and by means of these two common media, I am making a claim. By collecting and arranging moments of experience I venture to give what has come to be understood as common and all so familiar a distinct identity. Each work is an expression of a specific condition, something that can be intersubjectively perceived, subsequent to combining the two elements of language and photography by means of human understanding.

Die kontinuierliche Nivellierung raumzeitlicher Entfernungen hin zu einer globalen Vereinheitlichung und Vereinfachung macht zugleich unser erfahrungsweltliches Verstehen um ein Vielfaches komplizierter. Durch die Entstehung einer universellen Sprache wachsen zugleich auch die Möglichkeiten des Mißverstehens. Bedeutungen verändern und verschieben sich: das jeweils Gewohnte wird dem Alltag entzogen, das Bekannte entfremdet, plötzlich stehen wir vor neuen Begriffen für das, was wir immer schon zu kennen glaubten und erfahren sie als mehrdeutig und widersprüchlich. "Immer mehr Urlauber suchen die unberührte Natur." Die Verwirrung ist es, die universell erscheint. Trotz aller Entwicklungen bewahren sich dennoch Grundstrukturen, halten durch, gleichwohl sie ständig überspielt oder als überholt bezeichnet werden.

Das Sammeln von vereinzelten Erfahrungsmomenten und deren Zusammenfügung vermittels der Aufnahme dessen, was wir greifbar vorfinden – sowohl sprachlich wie auch fotografisch – ist mein Versuch, den austauschbaren und verstückelten Gegenständen der alltäglichen Welt wieder eine spezifische Identität zu geben: reale Sprach- und Bildfragmente, die ihrer Festigkeit verloren zu gehen drohen. Jede meiner Arbeiten ist deshalb ein Ausdruck eines spezifischen Zustandes, etwas intersubjektiv Nachvollziehbares, jedoch nur durch die Verbindung der sprachlichen und fotografischen Elemente, die zusammen ein Ganzes erst im Verstand des Betrachters erzeugen werden.

GIULIO PAOLINI

1940 Born in Genoa. Lives in Turin.

Solo exhibitions

1990 *Hortus Clausus: a work from 1981*, Stein Gladstone Gallery, New York

1991 *Come non detto*, Galleria Marilena Bonomo, Bari
Rialto, Studio d'Arte Barnabò, Venice
Hotel de l'Univers, Villa delle Rose, Galleria Comunale d'Arte Moderna, Bologna
Anteprima, Castello di Rivoli, Rivoli
Metafore (with J. Kounellis), Galleria dell'Oca, Rome
Il teatro dell'opera, Galleria Franca Mancini, Pesaro
Stein Gladstone Gallery, New York

1992 *Pièce unique*, Galleria Amelio-Brachot, Paris
Galleria Lucio Amelio, Naples
Impressions graphiques, Bonner Kunstverein, Bonn
Galleria Christian Stein, Milan
Galleria Christian Stein, Turin
Galerie Yvon Lambert, Paris
Galerie Di Meo, Paris
Galleria Marco Noire, Turin

1993 *Impressions graphiques*, Kunstmuseum Winterthur, Winterthur
Galerie Annemarie Verna, Zurich
Galleria Locus Solus, Geneva

1994 *L'opera in palio*, Palazzo Patrizi, Siena

1995 Marian Goodman Gallery, New York
Múltiplas e Obra Gráfica 1969–1995, Fundação Calouste Gulbenkian, Lisbon
Galleria Sperone, Rome
Lezione di pittura, Milleventi e Bloomsbury Books & Arts, Turin
Palazzo della Ragione, Padua

1996 Villa Medici, Rome

Bibl. *Giulio Paolini*, Palazzo della Ragione, Milan, 1995.

Statement

N. O.: C'è un momento nella tua ricerca in cui fare il quadro è, diventa scrivere il quadro.
G. P: La descrizione dell'opera, il suo titolo, prende il sopravvento e si pone come un momento da percepire e trova, in questo senso, ogni volta un suo modo precipuo di svolgersi.
N. O.: Perché?
G. P: Per voler dare un limite superiore all'immagine. Confermare attraverso la parola la disponibilità dello spazio.
N. O.: Quanto c'è di letterario, di narrativo in te? Perché mi sembra di avvertire in te un'urgenza di raccontare.
G. P: Direi che se c'è un aspetto letterario è sempre dato per sottrazione. Forse in tutti i miei lavori c'è un alone letterario, suggerito, lasciato lievitare per insufficienza e precarietà del dato visivo.
Nico Orengo, Maggio, 1973
(from: Maddalena Disch, *Giulio Paolini*, *La voce del pittore*, ADV Publishing House, Lugano, 1995.)

OLIVIER RICHON

1956 Born in Lausanne. Lives in London.

Solo exhibitions
1990 Jack Shainman Gallery, New York
 Lawrence Olivier Gallery, Philadelphia
 Galerie Samia Saouma, Paris
1991 Espace d'Art Contemporain, Lausanne
1992 Galerie des Beaux-Arts, Nantes
 University Gallery, Essex
 Galerie Samia Saouma, Paris
1993 Jack Shainman Gallery, New York
 Galerie de l'Aquarium, Valenciennes
1994 Forum Stadtpark, Graz
1995 Espace d'Art Yvonamor Palix, Paris
 Estop Gallery, Bath
 Zone Gallery, Newcastle
 Portfolio Gallery, Edinburgh
 Montage Gallery, Derby
1996 Art Frankfurt 1996, Stand Françoise Knabe,
 Frankfurt am Main
 Galerie Françoise Knabe, Frankfurt am Main

Bibl. *Olivier Richon,* Espace d'Art Yvonamor Palix, Paris, 1995.

Statement

The relation of a spectator to an image and that of a reader to a text unavoidably privileges the eye as a mediating organ. The eye swallows everything, obliterating the difference between the written and the visual. Otto Fenichel, in "The Scoptophilic Instinct of Identification" (1935), is interested in the relation between seeing and devouring. He mentions Strachey's work on reading: for the unconscious, to read would represent the idea that sentences, words and letters are objects to be devoured by the eye. The expression "a devouring eye" reminds us of the oral dimension of visual experience. To read a text or to look at an image is a form of incorporation where objects are absorbed by the eye, an organ not unlike the mouth. Eye and mouth are linked for the printer Fournier, as typography "paints speech and speaks to the eye." Bodoni also celebrates the visual and fixed features of typography, which preserves the body of letters "with sharper outlines than the articulation of lips can give them." (from: Olivier Richon, "Looking & Incorporating", *Camera Austria,* No. 37, 1991.)

KLAUS STAECK

1938 Born in Pulsnitz near Dresden. Lives in Heidelberg.

Solo exhibitions
1990 Kunstmuseum, Göteborg
1991 Museo Español de Arte Contemporáneo, Madrid
1992 Biblioteca Publica, Rio de Janeiro
 Städtische Kunstsammlungen Cottbus
 Akademie Galerie (Marstall), Berlin
1993 Kulturzentrum, Istanbul
 Aspekte Galerie, Munich
1994 Stadtbibliothek, Duisburg
 Hammer Museum, Los Angeles
 Rathaus, Rostock
 Galerie am Ratswall, Bitterfeld
1995 Staatsbibliothek, Göttingen
 Museum Haus Kasuya, Hirasaki
1996 Stadtbibliothek, Helsinki
 Bergen Billedgalleri, Bergen, Norway
 Retrospektive, Reum AG, Hardheim/Odenwald

Bibl. *Klaus Staeck, Standort Deutschland,* Steidl Verlag, Göttingen, 1996.

Statement

Am Anfang war das Bild
– auch wenn der Evangelist Johannes behauptete: Am Anfang war das *Wort.* Jedenfalls nicht die Schrift, das geschriebene Wort, der Text.
Meine erste Plakataktion startete ich 1971 in Nürnberg mit einer Bild-Text-Collage: Albrecht Dürers Porträt seiner alten Mutter, ergänzt durch die Zeilen "Würden Sie dieser Frau ein Zimmer vermieten?". Die hehre Kunst, der distanzschaffenden Aura entkleidet, konfrontiert mit jener rauhen Wirklichkeit, die dem Anspruch der Kunst nur selten gerecht wird. Die Botschaft ohne klar definierten Adressaten und nicht erkennbarem Absender erreichte dennoch ihr Ziel. Das ganze Geheimnis: die augenfällige scheinbare Unvereinbarkeit zwischen Text und Bild provoziert eine Spannung, die zur Beschäftigung, zum Nachdenken einlädt, nicht zwingt. Fast alle meine Text-Bild-Montagen leben von diesem dialektischen Widerspruch, machen auf den ersten Blick neugierig und sind angewiesen auf die Chance des zweiten Blicks: auf das Bild hinter dem Bild, das sich der Betrachter selbst macht.
Meine Arbeitsmethode setzt fast immer beim Text an. Meist ist es ein bekannter Slogan, ein Sprichwort, eine Redensart, ein Werbelogo, ein Schlagwort, jedenfalls etwas Vertrautes – oft von mir leicht abgeändert, gelegentlich pur. Juristische Schwierigkeiten

sind so programmiert. Der FAZ-Slogan "Dahinter steckt immer ein kluger Kopf" ist warenzeichen-rechtlich geschützt. Die "Shell-Werbewochen" mit der verheißungsvollen Ankündigung "Die Küstenbewohner können ihre Ölheizung jetzt direkt ans Meer anschließen" in Verbindung mit dem Foto des real gestrandeten Öltankers Amoco Cadiz provozieren die Frage, wo denn diese Anschlußstelle sei. Bewährt haben sich für meine Arbeit besonders Texte, die sich den Anschein einer offiziellen Bekanntmachung geben, ergänzt durch stilisierte Wappensiegel oder sonstige Rituale aus dem Innenleben der Bürokratie.

Oft geht es mir um Wörtlichkeit. Denn natürlich gefährdet jeder Friedensschluß Arbeitsplätze in der Rüstungsindustrie. Der im übertragenen Sinne häufig gebrauchte Satz "Laßt uns nicht im Regen stehen" bekommt im Zusammenhang mit einem Foto von im sauren Regen gestorbenen Bäumen einen erschreckend realen Sinn. Der alte DDR-Slogan "Im Mittelpunkt steht immer der Mensch" bekommt einen makabren Sinn, wenn der reale Kopf ersetzt wird durch jenen für Laien unentschlüsselbaren Strichcode, der inzwischen fast alle Lebensmittel ziert.

Es ist eine Wechselwirkung zwischen Vertrautem und Unerwartetem, die neugierig macht. Diese Form der Bild-Text-Collage ist eine aufdeckende Methode, keine verrätselnde, verschleiernde. Sie macht Widersprüche sichtbar, Prozesse durchschaubar und ist ein adäquates, äußerst produktives Mittel der Aufklärung.

This book is the official catalogue for the exhibitions entitled *photo text text photo* at the MUSEION – Museum für Moderne Kunst, Bozen from September 13th to November 17th, 1996, and the Frankfurter Kunstverein from January 21st to March 3rd, 1997.

Curators
Andreas Hapkemeyer
Peter Weiermair
Editorial assistance
Ulrike Schork

Photo credits
Edition Staeck, Heidelberg
Paolo Quartana, Bozen
Christian Kunigk, Munich
André Morain, Paris
Hanni Schmitz-Fabri, Cologne
Christian Carrieu, Paris

Photos courtesy by
Marco Noire Gallery, S. Sebastiano/Po
Galerie Klemens Gasser, Cologne
Galerie Chantal Crousel, Paris
Barbara Gladstone, New York
Sidney Janis Gallery, New York
Monika Sprüth Galerie, Cologne
Galerie Tanit, Munich

Copyright © 1996 by MUSEION – Museum für Moderne Kunst, Bozen, Italy and Frankfurter Kunstverein, Frankfurt am Main, Germany and EDITION STEMMLE AG, Kilchberg/Zurich, Switzerland

Translations from the German by John S. Southard
Editorial direction: Esther Oehrli
Art direction and typography: Peter Renn • Typografie, Teufen, Switzerland
Photolithography: Colorlito Rigogliosi S.r.l., Milan, Italy
Printed and bound by: EBS Editoriale Bortolazzi-Stei s.r.l., San Giovanni Lupatoto (Verona), Italy

ISBN 3-908162-48-3